D0469091

How to
Use Filters

Minolta Corporation
Ramsey, New Jersey

Doubleday & Company
Garden City, New York

Minolta Corporation
Marketers to the Photographic Trade

Doubleday & Company, Inc.
Distributors to the Book Trade

Library of Congress Catalog Card Number: 81-71221
ISBN: 0-385-18148-5

Cover and Book Design: Richard Liu
Typesetting: Com Com (Haddon Craftsmen, Inc.)
Printing and Binding: W. A. Krueger Company
Paper: Warren Webflo
Separations: Spectragraphic, Inc.

Manufactured in the United States of America
10 9 8 7 6 5 4 3 2 1

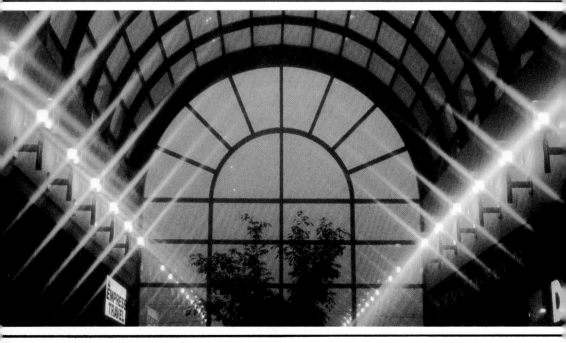

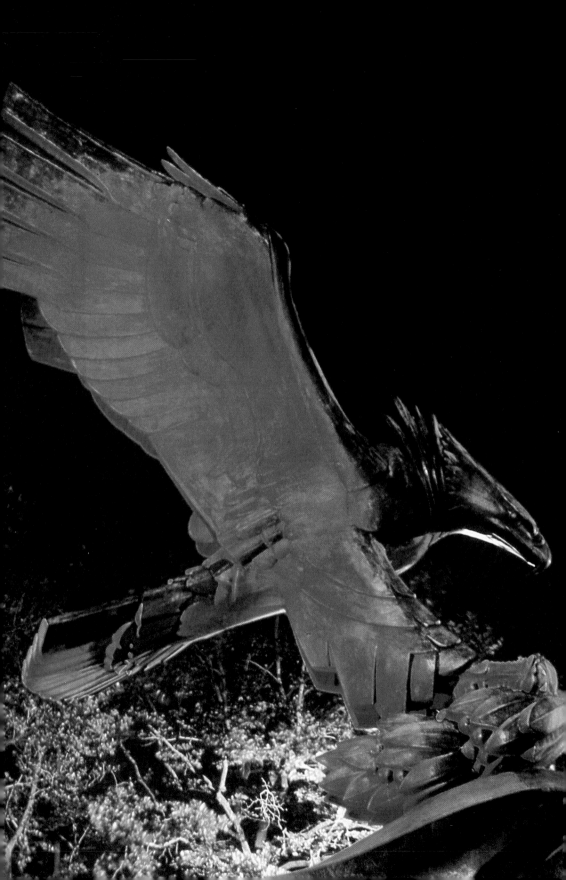

Contents

Technique Tips

Throughout the book this symbol indicates material that supplements the text and which has been set off for your special attention. You can apply the data and information in these Technique Tips immediately to get better results in your photography.

Introduction

Pictures that dazzle the eye. Pictures that affect your emotions. Pictures that reach out and grab you with excitement and visual power. These are the kinds of pictures everyone wants to make, but not everyone knows the secret. These are the kinds of pictures you can make with those simple but amazing photographic accessories called filters.

One of the great things about filters is that you can use them to extend your picture-making capabilities no matter what kind of camera you have. Of course you can already do a great deal in creating pictures through your choice of film, lens, composition, exposure, and processing. But there are limits to these controls. When your visual imagination goes beyond those limits, you need new techniques of expression and new methods of control. That's when filters can become your most important accessories—the keys to new image-making.

At one level filters are workaday devices. They help you make pictures that are precise, accurate, and true to the subject in subtle as well as fundamental ways. They give you technical mastery without the need for a great deal of technical knowledge. You can control color balance, exposure, contrast, or many other factors, simply by putting the correct filter in front of your lens and letting the camera do the rest.

At another level, filters are the secret of creative freedom. They are windows through which you can sight—and capture—images such as the eye has never seen before. You can produce colors and effects that take your pictures into the realm of drama, fantasy, romance, or shock. You can surprise and delight the eye with rainbows, stars, colors, blurs, and image combinations that are truly original and exciting.

Some images of this sort are the result of planning and deliberate working methods. Others are the result of experimentation, of happy accidents recognized and used for their real value. Whether you know beforehand how to achieve an effect, or discover the method in the course of picture-taking, you'll find it is easy to repeat your successes and to develop variations that can be used expressively with other kinds of subject matter.

Imaginative and thoughtful use of filters produces spectacular pictures. A color control filter ensured beautiful skin tones here, a double exposure with a special-effect filter created the rainbow colors. Photo: R. Farber.

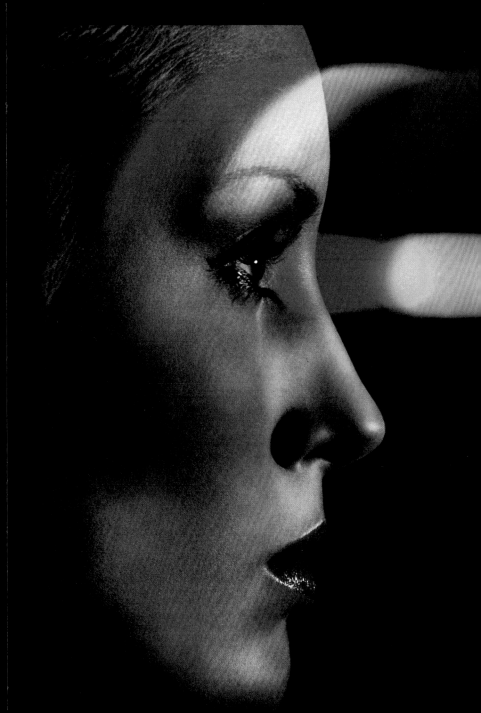

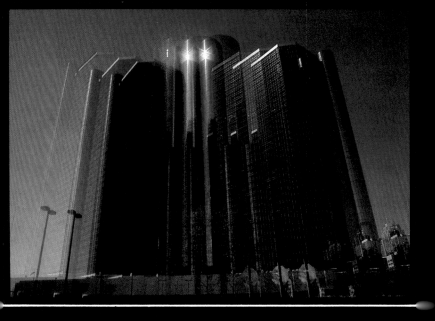

The pictures on these two pages are all of the same subject; they show some of the fascinating image manipulations you can achieve with filters and other lens attachments. Here, three exposures were made, each through a different filter: red, green, and blue. The tripod-mounted camera was shifted slightly after each exposure. Photo: D. Cox.

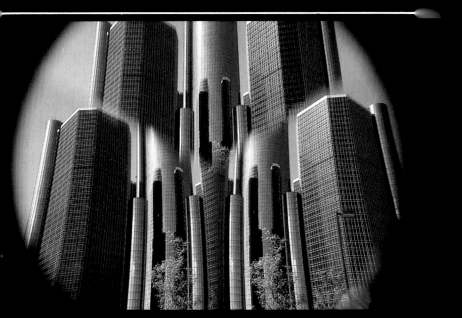

combination of a multi-image prism and a variable red-blue filter produced this image with single exposure. Photo: D. Cox.

Filters are simple devices, easy to use. But their effects can be profound. This book is about both those things: use and effect. It shows you the simple, direct ways to use filters to solve technical problems and expressive problems. It helps you understand what filters can do and how to get them to do it for you. It shows you how to control your pictures. It also shows you the enormous range of ordinary and special effects you can obtain. In short, this book serves as a source of technical information and technique, and as a source of creative stimulation.

The photographs in each chapter are exciting and informative. They do not show the limits of what you can do with filters, they show the potentials. From seeing how a filter solves a problem or adds expressiveness in one situation, you can go on to visualize its use in other situations.

The written material is your source of information. The captions for the illustrations tell you how and why filters were used to achieve what you see—or what you do not see when corrective filtration has been used. The text in each chapter gives you working methods and specific data and explains the principles by which control and effects are obtained.

Study the pictures in relation to the captions and text information so that you understand how the results were achieved. In that way you will gain real knowledge of filters, for knowledge is the ability to put information to work in solving your own problems.

When filters are used correctly, the things you see look better—more exciting, more appealing, more expressive . . . as you will see

1

What Is a Filter?

A filter is a kind of specialized sieve for light. Its function is to let some portions of the light falling on it pass and to prevent other portions from getting through. Light is composed of energy wavelengths to which the eye can respond. However, wavelengths are a scientific concept; the eye sees wavelengths as colors. So, a filter is a color control device; it lets some colors pass and blocks others.

White light is composed of all the visible wavelengths (all the colors) and we describe a filter's action in terms of what it does to white light. A blue filter, for example, transmits only the blue wavelengths in white light and absorbs, or blocks, all the others. The simplest way to tell what color a filter passes is to look through it at a white surface. The color you see is what the filter transmits; everything else is stopped.

There are some filters that operate on the ultraviolet and infrared wavelengths, which we cannot see but which can be photographed under certain conditions. These filters can be just as important in controlling results or creating special effects as filters which operate on the visible wavelengths.

There are a number of other devices that are placed in front of the lens and used like filters. These devices include diffusers, which soften an image; polarizers, which control glare and reflections; diffraction gratings, which break white light into rainbowlike spreads; multi-image prisms; supplementary lenses for very close focusing; attachments that permit simultaneous near and far sharp focus; and a variety of mattes and masks that produce pictures within silhouette shapes, or that permit you to combine two or more images in ingenious ways without the need for special darkroom work.

All of these filters and devices—and many more—are covered in the following chapters. The first matter of importance is: What can filters actually *do?* The short answer is that they can create fascinating visual effects. They also can help you bring difficult picture situations under control.

A medium yellow-green filter, commonly used with black-and-white film transmitted the green of the foliage and added its own color to the direct and reflected white light in the scene. The result is a richly appealing interpretation. Photo: J. Scheiber.

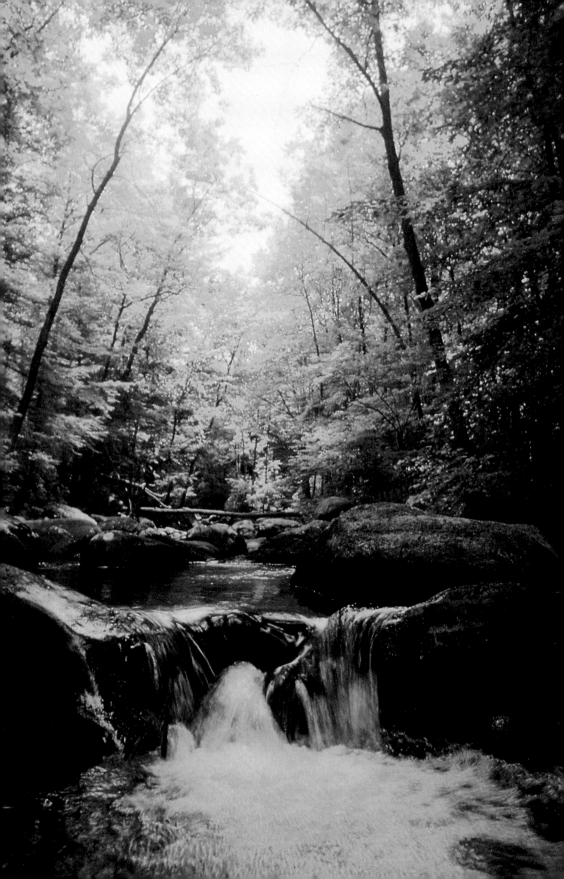

Creative Effects in Color

The striking effects you see in the pictures here have all been created by the imaginative use of filters and special-effect devices. These, and the images on the next several pages, are just an introduction to what you can do. The captions will help you understand the nature of the effect. They also will tell you where to turn in the book to learn how to create that kind of picture and many variations that use related techniques.

Fog and diffusion filters create soft effects; see p. 26.

Strong colors can add drama as well as mood; see p.26

Filters on a flash unit and the camera lens produced the results above and left; see p. 36 to learn the technique.

More Creative Color Effects

The key to using special effects is to make them appropriate as well as expressive—that is, to use a special effect for what it adds to the subject. An effect can be delicate or bold, but it should be suitable. If you want to impart a misty blue glow to an image, it will be far more effective for a picture of young lovers than for a picture of a ham sandwich.

Filters can color light as well as the image; see p.38

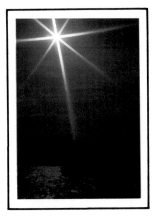

To learn to create stars and other effects, see Chap. 3.

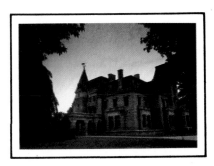

Monochrome subjects produce colorful images with half-color filters; see p. 34.

Creative Image Manipulation

A well-used effect accentuates or reinforces some visual aspect of the subject. Optical manipulation is one way to create images that the eye could never see directly but that have strong graphic impact and great expressive power. These effects can be combined with creative color effects for even more amazing results. Let your imagination go to work with them.

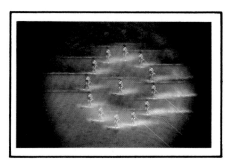

Repeat-image prisms multiply the subject in a single exposure; see p. 46.

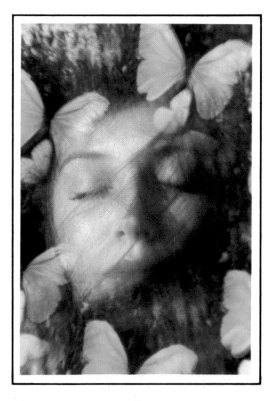

Double exposure and paired masks product this kind of image; see p. 48.

Spherical effects can be created directly with a fisheye lens, or by reflection in curved surfaces; see p. 53.

Adding color to a special image is an easy way to produce variations.

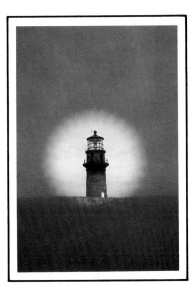

The degree of color effect depends on filter density; see p. 22.

Opaque or colored transparent masks provide spotlighting and unusual framing; see p. 34.

Color Control with Filters

One of the most important jobs a filter can do is to help you control things to get exactly the results you want. That often means getting natural-looking pictures under difficult, unnatural conditions such as light of a wrong color, or too much or too little light for normal procedures.

Unlike creating special effects, when you use a filter for control its effect remains invisible even though it is crucial to the success of the picture. Using filters this way is a subtle but powerful technique for creating truly expressive images. Here are some examples of filter control in color photography. The captions will tell you where to learn how to use these controls, and others, in your own pictures.

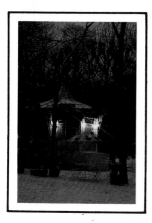

Filters can adjust for the color qualities of different kinds of light; see Chap. 5.

A conversion filter will adapt tungsten light to daylight color film characteristics; see p. 72.

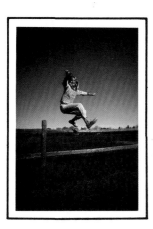

A polarizer can deepen blue sky color; see p. 80.

For selective focusing and exposure control, try a neutral density filter; see p. 65

Control in Black-and-White

Like color films, black-and-white films are sensitive to all colors of light, and so their results also can be controlled with filters. Many of the masterpieces of black-and-white photography owe their graphic impact to the use of filters. One major use is to make sure that various subject colors translate into appropriate, natural-looking shades of gray. Another is to control contrast so that the central subject stands out clearly and effectively. In addition, special effects are just as easy—and just as effective—in black-and-white as in color.

Use a polarizer for sky effects as well as reflection control; see p 89

To enhance portraits with filters, see p. 104.

Color from black-and-white? See p. 114.

Contrast control can be subtle or dramatic; see Chaps. 6 and 7

Filter Materials

Filters are used in two basic positions in photography. Most often they are used in the image-forming path—that is, the path of the light from the subject, through the lens, to the film (or printing paper). These are optical filters. The other position is in front of the light source to color the light before it reaches the subject, or the film in an enlarger. These are light-path filters.

Optical Filters. Only a few kinds of transparent materials are suitable for optical filters, materials that will not distort or degrade the image. These are optical resin (rigid plastic), glass, and thin sheets of gelatin.

By far the most popular, and most versatile, material is optical resin. It is the material used for distortion-free windshields in jet planes, for eyeglasses, and for a variety of other applications. It is optically pure, lightweight, and usable for special effect and conventional control filters alike. It is highly resistant to scratching from dust, dirt, or repeated cleanings. It does not require the delicate handling of gelatin or glass filters. It has so many advantages that it is now the most widely used filter material for all kinds of general and specialized photography.

Glass filters can be of excellent quality, and many photographers like them, but they have several drawbacks. They are heavier than rigid plastic, more expensive in most cases, and fragile. They are usually round, which limits their adapability to a variety of lens sizes (see the following pages), and most require special mounting rings or retainers. The range of special effect filters in glass is more limited than in rigid plastic.

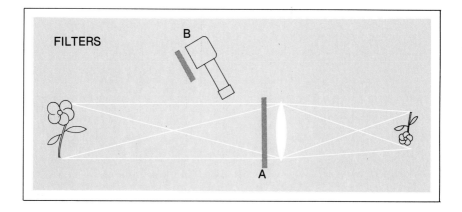

A filter used in front of a lens (A) is in the image-forming path and must be of optical quality so as not to degrade the image. A filter used in front of a light source (B) does not affect sharpness and related image qualities. These considerations apply to enlargers and projectors as well as cameras.

Gelatin filters are by far the most lightweight and least expensive, but they are also the most fragile. They are very useful for studio photography, but require awkward adapters and cannot stand up to the rigors of outdoor photography with a handheld camera. In addition, there are virtually no special effect filters made in gelatin, although there is a wide range of control filters for color photography.

Light-Path Filters. Filters used in front of light sources do not have to be optically perfect. Thick sheets of gelatin or cellulose acetate are commonly used for spot and floodlight filters. Large sheets of acetate are available for covering windows, for example to filter daylight so it will match interior light. Printing filters which slip into the light head of an enlarger are acetate. Dyed plastic and glass filters are used for many kinds of safelights, as are acetate sheets, and sleeves which slip over fluorescent tubes.

Dichroic Filters. A special kind of heat-resistant glass filter is used for the built-in filtration in color enlargers. This is an interference or dichroic filter. The glass is not colored or dyed, it is coated with microscopically thin layers of metallic compounds, much like the coatings used on lens elements. The coating causes a very specific group of wavelengths to be reflected away while allowing others to pass. This kind of filter is highly resistant to fading and does its job with great precision and efficiency; it is also very expensive compared to ordinary color-absorbing filters. Dichroic filters are not used at the camera lens except for very specialized work.

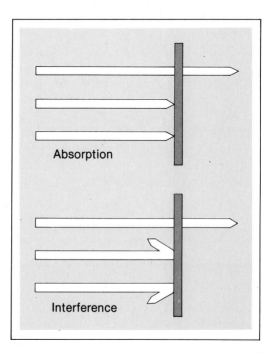

(Top) Most filters absorb various wavelengths in order to selectively transmit only a certain color. (Bottom) The coatings on dichroic filters interfere with unwanted wavelengths, reflecting them out of the transmission path. Dichroic filters are used primarily in color enlargers.

Filter Sizes and Mounting Methods

There are two basic shapes for camera-lens filters—round and square —but many different sizes. With square filters it is easy to standardize on one size big enough to cover the front-element diameter of all your lenses. That can save a lot of money because you can eliminate duplication. Round filters are available in exact sizes to fit almost all lenses, or in standardized "series" sizes which can be fitted to a range of lenses by means of step-up or step-down adapter rings that bridge the difference between lens and filter diameters.

Gelatin filters are supplied in squares that measure 50mm (2 in.) to 125mm (5 in.) on a side, but they can be cut to other sizes and shapes. The best way to do this is to sandwich the filter between two pices of tissue, mark the cutting outline on the tissue, and use sharp scissors.

Mounting Methods. The accompanying illustrations show the major methods of mounting filters on a lens. The most versatile method is used for square rigid plastic filters. The square holder itself allows a filter to be slipped part or all of the way in front of the lens, and can accept two or more filters or effect devices with ease. Snap-together plastic rings allow it to be mounted various distances in front of the lens, and to be rotated so the effect can be located in any part of the frame. This kind of holder will also accept gelatin filters in mounting frames or various devices you might custom make for yourself. This system has been used for decades by motion picture and studio still photographers; now its great versatility is available for use with all kinds of equipment, by all kinds of photographers.

Round filters that screw directly into the front lens threads are the most limited because their positions cannot be adjusted, and because they will fit only one size lens. The adapter-plus-retaining ring method of mounting round filters is a little less limited, but it does not allow shifting a filter off-center in the frame, and it is cumbersome for combining two or more filters or effects devices.

Whatever mounting method you use, remember that the filter becomes the front surface of the optical system. In that position it can pick up stray light and create image-degrading flare. For this reason it is just as important to use a lens shade in front of a filter, if at all possible, as it is to use one in front of a lens alone.

(Opposite page) Filter mounting methods. (Top right) Round threaded filter screws directly into lens; it must match lens size exactly. (Top left) Unthreaded round filter (B) fits inside step-up or step-down ring (A) which screws into lens. Filter is held by screw-in retaining ring (C). (Center) Slots in push-through holder (A) accept rigid plastic filters, gelatin filters in frames, or round filters. Holder can rotate to any position on lens-mounting ring (C). One or more extenders (B) adjust distance in front of lens for varied effects, can also be used as sunshade in front of filter. (Bottom left) Unframed gelatin filter slips into slot of plastic holder which attaches to lens via screw-in adapter ring, not shown. (Bottom right) Open square-U holder (A) attaches to lens with adapter ring, accepts gelatin filters in metal or cardboard frames. (B).

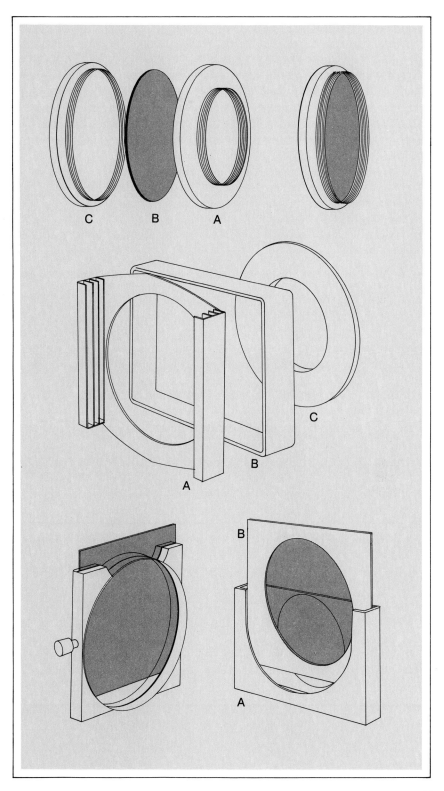

C B A

C

B

A

B

A

Color and Density

Filters come in almost all the colors of the spectrum and in neutral gray. Many filters are available in different strengths, or *densities*—for example, from the very faintest pink to a deep, dark red of the same hue. The various densities let you select different degrees of control. The stronger (more dense) a filter's color, the greater its effect. Its own color becomes increasingly predominant in the picture, and because it absorbs increasing amounts of light, more exposure compensation will be required. In some cases a filter's density is included in its name or designation, and can be used to directly figure exposure adjustment. This is explained where appropriate in this book. For the most part, in color photography you can rely on your camera meter to adjust exposure. All you have to know is that if you want a stronger effect you need a denser filter.

Filter Names and Classifications

Filters are commonly grouped in terms of their overall functions or applications. They are also individually identified by various names or numbering systems. The major functional classifications are given in the accompanying table.

Filter names often simply identify the color and relative density (light yellow, deep green, etc.), or the basic application (skylight) of the filter. Names for effects filters are sometimes descriptive, and sometimes merely dramatic (Rayburst, Spectral, Colorflow, etc.).

In general, names are cumbersome and imprecise for control filters, so most manufacturers use a number or number-plus-letter system of identification. A reference table at the end of the book compares the number-name systems of several manufacturers to help you identify equivalent filters for various applications. Not all filters can be handled in a single system. For example, color compensating and neutral density filters each have distinctive identification systems. These are explained at their appropriate places in this book.

FILTER CLASSIFICATIONS

Color and Black-and-White Photography

1. *Effects filters*—to change image color, definition, or other properties in ways that depart significantly from normal rendition.
2. *Control filters*—to control glare, reflections, exposure, color balance, and contrast.

Control Filters for Color Photography

1. *Conversion filters*—to match light source and film type.
2. *Light-balancing filters*—to make minor adjustments in the color balance of light.
3. *Color compensating filters*—to make slight adjustments in just one or two colors of light.

Control Filters for Black-and-White Photography

1. *Contrast filters*—to make major changes in subject (image) contrast.
2. *Correction filters*—to achieve natural-looking translations of colors into shades of gray.

The effects of increasing filter density are represented on the opposite page. (Top left) No filter; a silhouetted, essentially colorless subject. (Top right) Twenty percent red added. (Bottom left) Forty percent red added. (Bottom right) Fifty percent red added. The gray tone of the sky prevents the red effect from becoming overly dramatic.

2

Creative Color Effects

There is a wide variety of filters specifically designed to alter colors or otherwise change the image in highly expressive ways. These filters are not used to achieve literal representation of the subject, but to make interpretations. They can create mood and emotion; they let you be impressionistic rather than realistic.

One of the best things about these effect filters is the fact that they pose few technical problems. They are easy to use, with a minimum of fuss. For the most part you can see exactly what sort of effect you will get when you mount them on the lens. Then all you have to do is push the shutter release. In many cases it is not even necessary to worry about exposure compensation.

Aside from their technical ease, the appeal of these filters is the way they take the subject out of the ordinary and make it something visually special. Some filters produce subtle changes, others have extreme effects. Some affect the entire image area, others change only a portion of the image. In general, subtle effects are used to build or enhance mood and the emotional aspect of a picture. They are muted, understated; they work to reinforce qualities already present in the subject and to increase their effectiveness.

Strong, bold changes are used to make graphic impact the major point of a picture. The special effect may become the topic of the picture, while the objective subject matter in front of the lens serves primarily to show off the effect. This approach imposes a creative re-working, or remaking, on the picture; it shows what you can do to make the subject something else, something new and different.

The skill and taste with which you employ special effects is a mark of your creative ability. It requires visual imagination and intuition to use a special effect so that it is truly effective. The pictures in this chapter and the one following will give you many ideas. They show you some of the results possible with various kinds of creative effect filters and lens devices. The text explains how the pictures were made. That's all you really need to know in order to use the filters for your own ideas. It's easy to grasp the technique. What you do with it is up to you.

To color the subject but not the surroundings, filter the light sources. This spectacular effect was created with strongly colored filters in front of flood and spotlights. Photo: D. Gray.

Use a fog filter to enhance a romantic locale. Finely etched lines on the filter surface create a faint ghosting of the image that produces a soft veiled appearance. Photo: R. Farber.

Fog and Diffusion

Fog is composed of moisture droplets suspended in the air. These droplets scatter and reflect light to such a great degree that colors rapidly become washed out and subjects become completely obscured. Visually it is as if there were a light grayish veil obscuring the subject.

Fog filters simulate this effect by scattering light so that a kind of white veil appears over the picture. The result is not a realistic representation of actually looking into a fog, but a visual equivalent that looks and feels convincing. Most manufacturers offer fog filters in at least two strengths or degrees of diffusion. One is extremely slight and gives the impression of seeing the subject through a light mist. The other is considerably stronger; it "whites-out" surrounding detail and provides a definite sense of something in the air between the viewer and the subject in the picture.

Diffusion Effects. Diffusion filters are closely related to fog filters. They soften image details, but they do not create the overall sense of light-filled air that a fog filter does.

Image diffusion is a romanticizing and flattering technique. It is often used for portraiture to soften harsh lines and wrinkles, and to help emphasize the halolike effect of backlight on the subject. Diffusion filters are available in various strengths, and you can vary the effect of a particular filter by your choice of *f*-stop. The diffusion is greatest at wide apertures, and decreases as you close down to smaller apertures.

In addition to reducing image sharpness, diffusers and fog filters also soften colors and lower contrast. This is because they spread light from bright areas into immediately adjacent darker areas. You usually can rely on your in-camera metering system to provide accurate exposures with these filters in front of the lens.

It is possible to combine diffusers or fog filters with colored filters. Some manufacturers offer various pale colored filters with a fog or diffusion effect built in; these are often called mist or pastel filters. Their effects can be quite pleasing and expressive, but they are generally limited to light color densities.

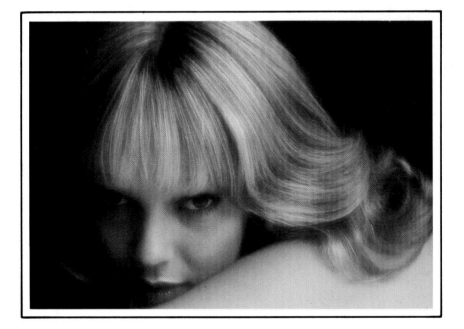

Diffusion filters are often used by portrait and glamour photographers to flatter subjects. Tiny lines and blemishes disappear and highlights are gently spread, giving a person a younger, more idealized look. Photo: J. Alexander.

Color Shifts

When realistic color is not your aim, filters that provide extreme color shifts can create exciting pictures. Effects of this sort are often seen on record album covers, posters, and other display pieces.

For dramatic color effects you need filters with strong color densities. A number of deep color filters especially for color photography are available under such names as POP filters, Vibraflow, and other terms. They are generally available in strong colors—blue, green, orange, red, purple, violet, and aqua—although no manufacturer necessarily offers all colors. They are strong enough to override the subject's natural colors and impart their own color to the picture.

Depending on their color and strength, and the kind of light, these filters may require from one to four or five stops exposure compensation. Most of them have a different exposure factor for daylight than

Very strongly colored filters produce essentially single-color images. A deep blue filter made this sun-lighted scene look as if it were moonlighted, a "day-for-night" effect. Photo: R. Mullin.

A deep red filter in front of a high-power electronic flash unit, close to one side of the subject, produced this intensely colored image. Photo: J. Peppler.

for artificial light, so it is important to make some exposure tests, or to shoot additional pictures at different exposures to be sure of getting the best results.

As you can see in the examples shown here, the color effect is extreme. Use these filters for drama, not for realism.

Other Methods. You can get selective color shifts by using color compensating filters, as explained in the chapter on control in color photography. Densities of 40 or 50 will generally create shifts that become quite noticeable. For extreme effects you can even use filters normally intended for black-and-white photography.

Keep in mind that you can also create color shifts by mismatching color film and the light source. To get an overall red-gold effect, use daylight film with tungsten illumination. To get an overall blue-white effect, use tungsten type film in daylight. The effects are limited to those two color ranges, but they are less intense than those produced by the special effect color filters.

A blue and tobacco (tawny brown) split-color filter matched this scene to subtly but very effectively increase its color qualities. Photo: C. Callahan.

Varied Color

There are a number of filters which provide varied and multiple color effects in a picture, and some filters which can change the effect they produce.

To get two distinctly different color shifts in the same picture, use a dual or split-color filter. This is a filter in which one half is one color and the other half is a different color. Examples are red and blue, or yellow and purple combinations. You can buy dual-color filters, or you can achieve a similar effect with a square filter holder by pushing different color filters halfway in from opposite sides. Because they are so close to the lens, the line where their edges meet in the center will be completely out of focus and unnoticeable.

Multicolor Filters. There are also multicolored filters which have three separate colors. Some have their colors in parallel bands or stripes, others have three pie-shaped wedges radiating out from the center. Typical color combinations are blue, yellow, and purple, or red, green, and blue. You can control the location of the colors in the picture simply by rotating the filter in front of the lens.

Varicolor Filters. An amazing kind of filter is truly variable in color or density. Such a filter is used in combination with a polarizer, or has a polarizing filter built into its mount. Single-color filters of this sort allow you to vary the effect from no color to maximum color effect simply by rotating the polarizing component.

Many varicolor filters are three-element packages: two color filters plus a polarizer. By rotating the elements you can go from full strength of one color, through the range of different proportion mixes, to full strength of the second color. The amount of exposure compensation these filters require depends upon the strength of the color effect you select; however, it is fairly high in most cases because you are using a polarizer and color filters in combination.

A polarizing varicolor red filter was set for maximum color density to obtain this striking evening scene. Photo: T. Tracy.

Rainbow Color

A rainbow results when white light is refracted in such a way that its wavelengths are separated and you see the full spectrum of colors. Scattered water droplets in the atmosphere or in the mist around a waterfall create this effect naturally. A prism will also separate the wavelengths of white light.

Diffraction Grating. The filterlike lens attachment that creates rainbow effects is called a diffraction grating. It consists of very fine lines etched into a surface at such close spacing (1,000 lines per inch, or closer) that they cause wavelengths of light to disperse as they pass through. The lines are invisible, but the result is clearly visible: rainbow streaks, rays, arcs or circles radiating from points of bright light in the picture. A similar device is made with millions of microprisms, rather than etched lines, on its surface. Often the effect looks like vibrant energy or ghostlike images moving through the picture. You can see the effect as you look through the lens, and no exposure compensation is required.

To get a rainbow effect with a diffraction grating, shoot directly toward an intense light source. Gratings for many different patterns are available. Photo: Cokin.

Technique Tip: Making Multiple Exposures

Some 35mm cameras have a special control which allows you to make repeated exposures on the same frame. If your camera does not have such a control, the following method works well with most models.

1. Before taking the first exposure, turn the film rewind knob *without* pushing in the rewind release. This will take up any slack in the film.

2. Take the first exposure.

3. *Gently* check the rewind knob to make sure the slack is still taken up. Then hold in the rewind release while you operate the thumb lever. This will cock the shutter without advancing the film.

4. Take the second exposure. Repeat the above steps for additional exposures on the same frame. Remember that exposure will build up each time in areas where elements overlap from shot to shot.

Multiple Filters. Another way to get a simulated rainbow effect, although without all the colors of the spectrum, is to make multiple exposures on the same frame through different colored filters. Anything that changes position from one exposure to the next will be recorded in different colors, while stationary picture elements will be recorded more or less normally. Rapidly flowing water, such as a fountain or a waterfall, is good for this kind of treatment. Other good subjects are tree leaves waving in the wind, skaters or dancers in light-colored clothing, and similar moving subjects.

In order to avoid overexposure of the unmoving elements, it is common to give half normal exposure through each of three different filters—for instance, red, green, and blue. Exposure will vary according to the coloring of the subject and the strength of the filters, so experimentation is essential, but that is fun and can lead to some amazing images. You also can create this multiple-color effect with a stationary subject by shifting the camera very slightly after each exposure. This is easiest if you mount the camera on a tripod.

Localized Color

Filters which let you create a color effect in one part of the image, without changing colors in the other parts, come in a wide range of colors and three basic designs: half-filter, graduated, and center spot.

Half-Filter. The most basic filter for localized color effects simply has color in half its area, the remainder is clear. By rotating the filter you can put the colored portion in the top, bottom, left, or right of the picture. You can create a half-filter effect by pushing a square colored filter only partway into its holder in front of the lens.

A half-color filter across the sky area adds richness to an otherwise rather colorless scene.

Graduated Filters. A more sophisticated version of the half-filter is the graduated filter. It is clear in one half, but somewhere near the center line it begins to build up color density which increases to a maximum at the opposite side.

The many different colors of graduated filters can be used for realistic or impressionistic effects. A blue filter may ensure that the sky is recorded as an effective blue rather than being washed out from overexposure. A graduated green filter used with the dense section across the lower part of the lens will enhance the color of the nearby grass in a shot across a lawn or in a landscape picture. A neutral gray graduated filter can be used to cut down extreme skylight or to reduce overexposure of objects close to the camera in flash pictures.

You can combine two graduated filters of the same color to get a more intense effect in one area, or you can sandwich two filters of different colors with their dense areas across opposite parts of the picture.

Center-Spot Filters. Center-spot or clear-spot filters are similar to graduated filters except that the clear portion is directly in the center, and the outer ring of color is the same density out to the edges. This lets you surround your sharp, natural color subject with a mood-creating color effect, or with soft areas of diffusion. The center spot will be most clearly defined when you use a short-focal-length lens and a small *f*-stop; it will be least noticeable with a long-focal-length lens at a large *f*-stop. You can combine gray center spot filters with overall single color filters to get unusual effects as well.

A blue clear-spot filter created this spotlighted emphasis. Clarity of spot edges depends on lens focal length, distance of filter from lens front, and f- stop used. Photo: C. Callahan.

Foreground-Background Color

A very strong graphic effect in color photography is to show a natural-color subject against an unusually colored background. The technique requires two filters, and a combination of electronic flash for the foreground subject and natural light for the background. You must keep the subject well forward of the background and positioned so that the sun is a sidelight or backlight rather than a frontlight.

The principle is this: You put a strongly colored filter on the camera lens to achieve the background effect you want, and a complementary colored filter on the flash unit. The flash will illuminate the subject with colored light, but the filter on the lens will neutralize that because it is the opposite color. (These color relationships are explained in Chapter 4.) The result is that the foreground subject comes through as if illuminated by white light, but the background—illuminated by the natural light—receives the full effect of the filter on the camera lens.

Exposure. Working out proper exposure for this foreground-background effect requires a bit of thought. Light from the background will be reduced by the lens filter; light from the flash will be reduced by the lens filter and by the filter on the flash unit. For example purposes, assume that each of these filters absorbs one stop of light. Here's how to proceed.

Determine proper exposure for the sunlighted background, including compensation for the lens filter. You must choose a shutter speed that synchronizes properly with your electronic flash unit. If the background exposure reading is $f/11$ at 1/60 sec. and you are using a filter with a one-stop exposure factor, you need $f/8$ at 1/60 for proper exposure. Adjust your camera and lens to these settings.

Now you must locate the flash unit at the proper distance for correct exposure of the foreground subject. You will have to use the flash in the manual mode of operation, and proper flash-to-subject distance must take into account the two filters. The original meter reading indicated $f/11$, but the filters reduce the light by a total of two stops, which is equivalent to $f/22$. So you must put the flash at the proper distance for an $f/22$ exposure.

If you are using a guide number for your flash unit, simply divide it by $f/22$ to get the distance. If you are using a calculator dial on the flash unit, set it for the normal, unfiltered exposure ($f/11$) and then look to see what distance is required for two stops less exposure ($f/22$). Place the flash unit that far from the subject.

In photographic terms, what you are doing is figuring the proper distance for 1:1 flash fill, taking into account the total factor of the two filters. For more information on figuring flash exposures, see the companion book in this series, *Flash Photography.*

Some manufacturers offer matched pairs of filters for this foreground-background effect. You can make tests with other filters to find a properly matched pair. Put one filter on the camera lens, and make exposures of a white or neutral gray surface with other filters in front of your flash unit. Make exposures at several different f-stops through each of the filters. Examine the results to find the shot in which the white or gray surface is properly exposed with no tinges of other color. Use that filter on the flash unit along with the lens filter to create the foreground-background effect.

Filtered Light

Filters are so commonly used in front of the camera lens that few people experiment with the effects produced by filtering the light and using the camera without a filter. That's too bad, because they are ignoring a versatile technique for producing multicolored subjects, backgrounds, and shadows—all in the same picture.

It's easy to experiment. With continuous light sources you can see the color effects you will get. With electronic flash you can't see the potential results directly, although you often can set up, using tungsten modelling lights in place of the flash units, then switch to the flash for the actual picture.

Working with colored light requires some trial-and-error, but you can avoid a lot of wasted effort by keeping two basic points in mind:

1. Film and light source should match. That is, use daylight color film with electronic flash, and tungsten type film with artificial light.
2. White and neutral-color subjects will reflect the colored-light effects without change; colored subjects will change the light. For example, if you shine a blue light on a white subject, the subject will appear blue. But if you shine blue light on a red subject, the result will be a black subject, because it cannot reflect blue wavelengths; the same thing would happen with green light. Fortunately, you can see this clearly and can avoid combinations that do not look well.

Because filters placed in front of the light sources will not be in the image-forming path, they do not have to be made of optical-quality material. You can use acetate, colored sheets of plastic, colored cloth or paper, shower curtains, or any other material that will transmit light and change its color. However, keep in mind that light sources, especially continuous sources such as tungsten lamps, generate heat. You must arrange to keep the filter far enough away from the bulb so it is not scorched, melted, or otherwise affected by the heat of the lamp. (Heat is not a problem with portable electronic flash units.) You do not have to make exposure adjustments for the filters in front of the light sources, because the light intensity is reduced before it reaches the subject. Therefore, a direct meter reading of the subject will indicate proper exposure.

A red-filtered background light turns blue seamless paper magenta. See how the gown picks up the different colors. Photo: V. Podesser.

Dyes, makeup, and other coloring agents may produce very different colors under ultraviolet illumination. No ordinary white light was used on the subject here, so only those substances that fluoresced under UV became visible and photographable. Photo: E. Stecker.

Ultraviolet and Infrared Color

Just beyond the ends of the visible spectrum there are wavelengths that the eye cannot see, but that can produce vivid and strange effects on color film. At the blue end of the spectrum there is ultraviolet energy, at the red end there is infrared. Taking pictures with either of these kinds of "light" is easy, and the results can be quite unusual.

Ultraviolet Fluorescence. Many substances glow, or fluoresce, with strange colors when illuminated with ultraviolet wavelengths. These substances include various dyes, paints, crayons, cosmetics, carbonated liquids, synthetic fabrics, and much more. You can see the fantastic and unreal colors they produce under ultraviolet, and you can photograph them on any kind of color film.

First you must illuminate the subject with ultraviolet. The easiest way to do this is with BLB (Black-Light Blue) fluorescent tubes. These are available in various sizes to fit standard desk and ceiling fixtures; many electrical and hardware stores carry them. Another good light source is an electronic flash unit. Place a No. 18A ultraviolet filter in front of the light head to stop visible wavelengths and transmit only ultraviolet.

All films are sensitive to ultraviolet, but you will want to photograph only the visible, fluorescent colors. A No. 2A or 2B filter over the camera lens will screen out ultraviolet scattered from the source or reflected from the subject and surroundings, so that only the visible effect will be recorded on the film. Work in a dark room to eliminate other visible light.

For a basic exposure, set your exposure meter to the normal ISO/ASA rating of the film, but take additional exposures at larger and smaller *f*-stops to be sure of getting good results. Use filtered electronic flash to stop action such as the movements of a dancer, or the flow of a fluorescing liquid.

Infrared Color. Sunlight and tungsten light give off significant amounts of infrared, which is reflected by living organisms and many other materials. There is one color film which is sensitive to these invisible wavelengths, Kodak Ektachrome Infrared Film. It is also sensitive to visible light, so the effects it produces are a combination of visible and infrared exposure. The effects are unpredictable because you cannot see the infrared, and because the film emulsion has a color balance very different from conventional color films.

The best way to use this film is with a medium yellow filter over the camera lens to block blue and ultraviolet wavelengths so that the infrared exposure has significant effect. You can vary results by using a lighter or a darker yellow filter.

Exposure meters cannot measure infrared, so exposure is a matter of experience. However, you can start by metering the visible light and making additional exposures of at least one stop more and less than the meter indication. In daylight set your meter for a film speed of 125; with tungsten photoflood lamps try a speed rating of 50.

You won't know what the results are until you see the processed film, but they can be exciting and bizarre.

Healthy foliage is rendered red by infrared color film, but you can vary the color effect greatly by your choice of filter. This exotic scene was produced by a deep green filter. Photo: D. Garvey/West Stock, Inc.

3

Special Effects

There are two basic ways to produce a special effect in a photograph: Either alter the image-forming performance of the camera and lens, or change the normal darkroom procedures.

Many photographers feel that special effects are primarily a matter of darkroom manipulation, and that if they do not do their own processing—or are not willing to pay extra for specialized lab work—they are confined to making straight images, especially if they take color slides. As you have already seen, that is hardly the case. Many of the most startling and effective special effects are achieved in the camera using simple techniques and a few accessories. In fact, it is usually easier—and the results look better—to produce effects in the camera than in the darkroom.

Special effects are not limited to controlling and changing subject colors. For example, diffusion effects or composite images made with matching pairs of masks can be achieved with fully natural subject color rendition or with extreme color distortion; the choice is yours.

Attachments that alter the lens performance or its field of view offer many different kinds of expressive effects. You can turn points of light into stars. You can get repeated, multiple images of a subject in a single exposure, or put the same subject in different locations in the scene. You can change the subject's shape, stretching or compressing it, or you can give movement to a stationary subject. You can combine images without the ghostlike show-through common to overlapping double exposures. You can take seemingly impossible combinations of extreme close-ups and distant views in a single exposure. You can explore the expressiveness of a tiny detail magnified to major importance.

All of these effects can be achieved in color or in black-and-white, and they can be combined with one another or with other filter effects. The basic methods are explained in this chapter.

The great appeal of special effects filters and lens attachments is the dramatic imagery they can produce. Here a deep orange-red filter was used in combination with an eight-pointed star screen to create a photograph with strong impact in a single exposure. Photo: C. Callahan.

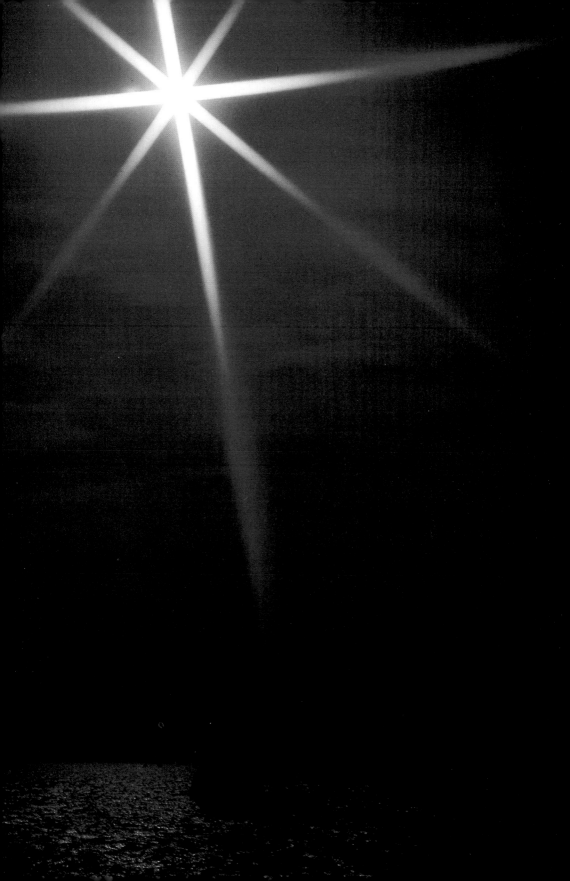

Stars

To create rays of light streaking outward from bright light sources in your pictures, use a star filter or star screen. This is a piece of clear material etched with crossed-line patterns which cause the intense light to form streaks or rays. Filters that create stars with two, four, six, or eight rays are available. You can use them alone or in combination with color effect filters. A variable star filter consists of parallel-line grids on two separate pieces of material mounted so that they can be rotated in relation to one another. When at right angles they form a four-pointed star effect with the rays at 90 degrees; turning one of the filters causes the star arms to come closer and closer together, creating increasingly narrow X patterns.

Stars will result only from intense, clearly defined light sources in the picture or from reflections of those sources in metallic or highly polished surfaces. The effect is strongest with light sources close to the camera, and when photographed at a medium aperture: $f/4$, $f/5.6$, or $f/8$. The effect also depends upon whether you use a filter with a coarsely etched pattern or a finely etched pattern.

Star effects are widely used for subjects such as nighttime street scenes, snowy landscapes, and pictures with a mystical or religious feeling. They are also used to romanticize bridal portraits, candlelit table displays, and similar subjects, and to dramatize the gleam of highlights on crystalware, polished silver, jewelry, and chrome trim. As with all special effects, the problem is to use them expressively, not tritely.

Homemade Stars. You can improvise a star screen by using scraps of window screening or other dark mesh material such as a black nylon stocking with a coarse weave. The star will have as many rays as there are corners in one cell of the mesh pattern. That is, a square will produce four rays, one from each corner, while a hexagon will produce six. You can sandwich two pieces of screening or mesh and rotate them in relation to one another to get combined effects, but this begins to get cumbersome and cuts out a great deal of light. Commercially made etched star screens are much more efficient.

(Opposite page) A four-pointed star screen was used in combination with a medium green filter. The screen has been rotated so the direction of the rays complements the architectural design. Photo: P. May.

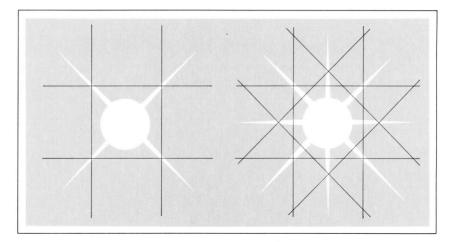

The number of corners in each cell of a mesh determines how many arms a star will have. (Left) A single piece of screening will produce a four-armed star. (Right) Two layers with their grid patterns at 45-degrees will produce an eight-armed symmetrical star. It is not practical to use more than two layers in a homemade star screen because of the amount of light blocked.

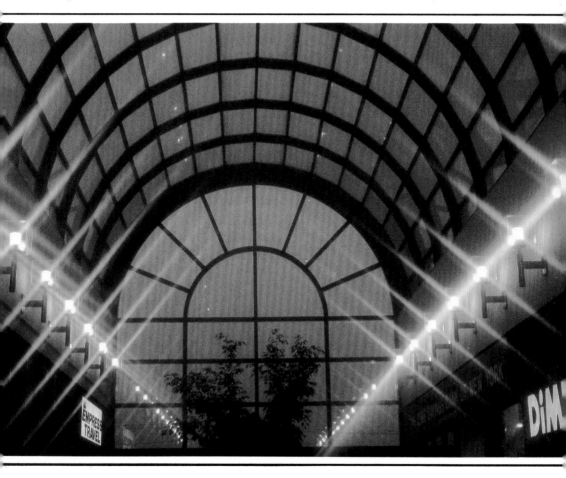

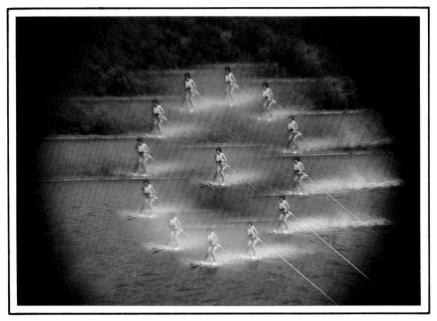

A multi-image attachment produced twelve repeat images in a circular pattern around a central image. The attachment was far enough in front of the lens to also produce a circular masking around the image edge. Photo: C. Callahan.

Multiple Images

You can get repeat images of a subject on the same frame of film with a single exposure by photographing through a multi-image prism attachment in front of the camera lens.

The prism is like a lens element, except that instead of having a smoothly curved spherical surface, it has from two to six or more flat faces set at different angles to one another. When used in combination with a normal camera lens, this creates an image in which the central subject is repeated once for each face of the prism. The image from each face is in a different place in the picture.

As the accompanying examples show, the prism faces may be arranged circularly around the center, or parallel to one another; each arrangement produces a distinct visual pattern. There are also variable prism attachments which have two faceted elements; rotating them changes the number and pattern of the repeat images.

Prism attachments do not require any exposure compensation. They can be used alone, or can be combined with color filters or with effect devices such as a star screen. There are even prisms that have color effects built into them. For example, a three-faceted prism with each facet a different color—red, green, and blue. Or a five-faceted prism with each face divided between green and orange. As with many other special-effect devices you can see exactly what you are going to get with a prism on the lens as you look through the viewfinder of a reflex camera.

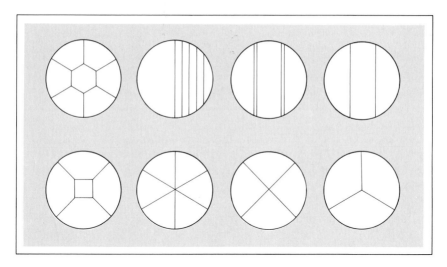

Some of the most common repeat-image prism patterns. Each facet produces a separate image of the subject in either a circular or a linear (parallel) pattern. Very closely spaced parallel facets produce an image overlapping that suggests movement.

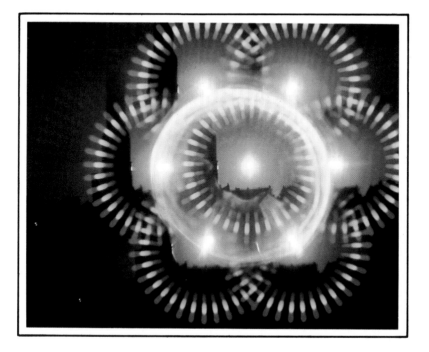

Creative visualization: a star-wheel diffraction grating was combined with a seven-image prism attachment for this dazzling image. Photo: D. O'Neill.

Masks

A mask is an opaque shield placed in front of the lens to cut off part of the picture during exposure. Masks are also called vignette attachments. The image recorded on the film is whatever shape is not cut off by the mask. You can create pictures of various shapes by using masks with cutouts of hearts, keyholes, stars, or many other designs.

A black mask will give you a shaped image in a dark surrounding. A white mask will make the shaped image appear to be floating in a colorless void, if you are able to illuminate the side of the mask facing the lens to the same degree as the subject. You can get similar effects with colored masks.

Base your exposure on a reading taken without the mask in place, whatever kind of mask you intend to use. You want the visible part of the subject to be properly exposed. If you took a reading through the mask, it would be overexposed because the meter would not realize that the masked-off part of the frame was unimportant.

Combined Images. You can use pairs of masks to create combined exposure effects without elements from one exposure showing through as ghost images in the other, as in ordinary double-exposure pictures.

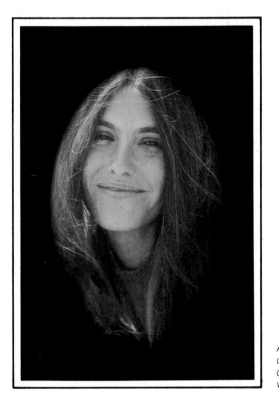

A simple black oval mask was used here. Close-range portraits or single, bold subjects look best with this treatment. Photo: Cokin.

The technique is first to take a picture with one mask in place. Then you replace it with an oppositely matched mask, one which covers the exposed portions of the film and leaves the previously unexposed portions uncovered. You make a second exposure through this mask without advancing the film.

For example, to insert one image in the center of another, you use an opaque mask with a clear center to make the central image exposure. Then you use a matching mask that has an opaque center but a clear surrounding area.

It does not matter which mask of a pair you use first, and the exposure is the same in both cases, as established by a meter reading without either mask in place.

If you mask first one half of the picture, then the other half, you can show the same person on both sides, or on the top and the bottom. Some square filter holders have registration marks or notches so you can use a single mask and locate it accurately from each side. Otherwise you can get proper registration by sliding the second mask in until it touches the first mask in the center of the frame before removing the first mask.

With a normal focal-length lens at medium or large *f*-stops the mask edges are out of focus so that they blend unobtrusively with the surrounding picture area.

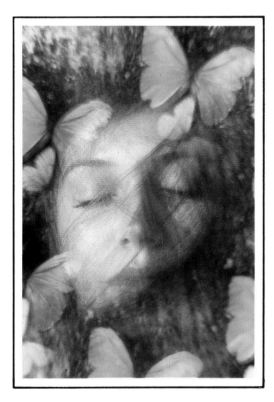

A mask-pair produced this image. First, the face was photographed through an open-center mask. Then the butterfly pattern was photographed in a double exposure with a matching mask with an opaque center and clear outer area. Exposure was normal in both cases. Photo: Cokin

Stretching Movement

The fantastic shape and movement distortions that you see here are achieved by using a special mask to create a kind of slit shutter for your camera. The mask is opaque and has a narrow slit in its center. As a result, the lens can form only a narrow band of image on the film. If the film moves past this image band during an extended exposure and the subject is moving in front of the lens, then the subject will be continuously recorded at various points on one long section of the film. The final image shows a stretched or compressed subject shape in front of a blurred background.

It is virtually impossible to predict what the image will look like, because it depends on the subject speed and the film movement speed, and whether these elements are moving in the same direction or in opposite directions. The technique is a little tricky at first, especially in determining proper exposure, but the effect is so unusual that it is well worth the time and trouble of experimentation. Here are the basic steps:

1. Load your camera with film, and with the lens cap on advance the film completely so that it is all on the take-up spool.
2. Use a wide-angle lens, and mount the camera on a tripod; you will need both hands and a long exposure for this operation. Focus the lens at the distance at which the movement will occur. Then mount the slit mask in front of the lens.

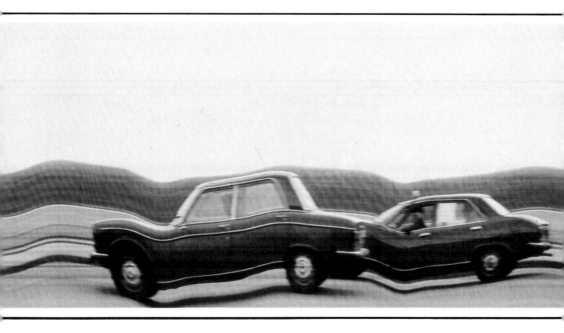

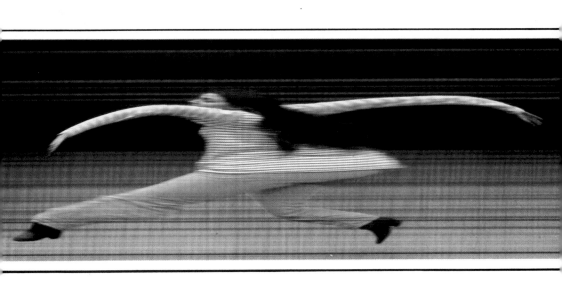

The technique for obtaining stretched images like these is described in the text. The most important factor is turning the film rewind crank smoothly and at a constant rate. Camera movement during the exposure will produce vertical dips, as in the picture of the cars.

3. In bright sunlight try a beginning test with the lens set at $f/8$. This is not an accurate value, because the light is decreased by the slit in the mask, which acts as a kind of f-stop. On your first roll try some tests at larger apertures as well; it will seldom be necessary to close the lens smaller than $f/8$.
4. Press the rewind release on your camera so you can rewind the film smoothly. Then open the shutter on the B or T setting to keep it open throughout the exposure. Have the subject start moving, and at the same time rewind the film past the slit image in the camera.

It is important to keep the camera as steady as possible and to wind the film smoothly and steadily for even exposure. Only experimentation will teach you how fast to rewind the film. Subject movement should be across the field of view—left to right, or right to left—not toward or away from the camera. You will get the greatest stretching of the subject when it moves in the opposite direction to the film. When subject and film move in the same direction the image will be compressed to some degree.

You can use the slit-mask attachment to get a sharp image of the foreground subject with the background blurred, as if it had moved. Use a long focal-length lens, and keep the subject well separated from the background. The subject remains stationary as you crank the film through the camera; the background, being somewhat out of focus, will be recorded like a moving blur.

Simulated Movement

A visual sense of movement can give excitement and drama to what otherwise might be a rather ordinary subject. Visual clues to movement in still photographs include repeated images, blur, and distorted shapes. There are various ways you can photograph a stationary subject and include these clues so that it looks like you recorded movement.

Linear Prisms. To get distinct multiple images in a single exposure, as if taken by a repeating flash unit, use a six-faceted parallel, or linear, prism. Five narrow faces, side by side, occupy one half of this prism, the sixth face is the entire second half.

A similar device has many more faces, much more closely spaced on one half of the prism. This is an action-making device, because the very close spacing of the many facets blurs or blends their images together. The effect is that the subject has moved through the picture and stopped in the final position—a kind of subject zoom movement. You can make the apparent movement vertical or horizontal simply by orienting the prism appropriately in front of the lens.

Slit Apertures. To create blurred shape distortion, use an opaque mask with a small cross-shaped opening in the center, a short curved line, or a short diagonal. This acts like a lens aperture, but the image can stretch and spread more in one dimension than another. The result is a visual equivalent of movement distortion.

Non-circular apertures will produce distorted images. Make very small openings in stiff, opaque material such as heavy duty aluminum foil. Use them in front of the lens, like a filter, or mounted in place of the lens to form a kind of pinhole camera; the effects will be different. Through-the-lens metering will give accurate exposures in most cases.

Optical Distortion

There are other ways to distort an image which you can improvise very easily. Shoot through pieces of distorting glass or plastic such as the ribbed materials often used for cabinet doors. Or try glass bricks used in construction, or a thick paperweight or glass ashtray. You can even try the bottom of a glass bottle, either colored or clear.

To make a distorting lens attachment, smear petroleum jelly on a piece of clear plastic. Or pour model airplane cement on a piece of scrap plastic or glass and let it dry in puddles.

Mirrored surfaces that are not completely flat will cause image distortions just like the mirrors in a carnival funhouse. Try the mirrored spheres sold as garden ornaments, or the highly polished side of a household coffeemaker or kitchen pot or pan. Tie or tape a ferrotype sheet from a photographic dryer into a curved shape and use it as a distorting mirror. Stretch a thin sheet of mirrored plastic film—the kind sold as a "space blanket" in sports stores—over a frame made out of stiff wire. You can bend it into any shape to produce ripples, curves, and other distortions.

Lens Distortions. The simplest way to get image distortion is to use a standard wide-angle or very-wide-angle lens and bring it as close as possible to the subject. Distortion results because the parts of the subject closest to the lens are magnified to a much greater degree than the parts that are farther away. When used from above or below a subject, the result is a dramatic exaggeration of height. When used for a portrait, the result is a grotesque nose, chin, and lips.

A cluster of flowers photographed through distorted glass is pictured here. When an optically uneven material transmits light, unusual shapes are formed.

53

Close-up Attachments

Close-up attachments, or supplementary lenses, allow you to focus much closer to the subject than the normal minimum focusing range of the camera lens. You simply put the attachment in front of the camera lens, like a filter; the camera lens is usually focused at infinity.

Supplementary lenses are rated in positive powers: $+\frac{1}{2}$, $+1$, $+2$, and so on; the higher the power, the closer you can focus and the bigger the image. A reflex-viewing camera will show you exactly what you are getting. With non-reflex cameras, you can find the focused distance this way: Divide 100cm (39½ in.) by the power of the supplementary lens. For example, with a $+3$ supplementary lens, a subject 33.3cm (13⅛ in.) in front of the lens will be in sharp focus.

Supplementary lenses do not require any exposure compensation. The accompanying tables show you what magnifications you can achieve with a normal (50mm) lens on a 35mm camera, and the maximum useful supplementary lens power with various other camera lenses.

MAGNIFICATION WITH 50MM CAMERA LENS
Focused at ∞

Supplementary Lens Power	Magnification*	Supplementary Lens Power	Magnification*
+½	0.025×	+6	0.30×
+1	0.05×	+7	0.38×
+2	0.10×	+8	0.40×
+3	0.15×	+9	0.45×
+4	0.20×	+10	0.50×
+5	0.25×		

*Image size on film will be this fraction of actual subject size.

SUPPLEMENTARY LENS LIMITS

Camera Lens Focal Length	Maximum Useful Supplementary Lens Power
Up to 50mm	+10
60–75mm	+5
80–125mm	+3
135–250mm	+2
250–500mm	+½

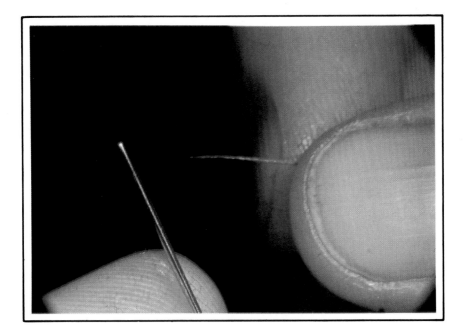

With a close-up attachment you can picture subjects which cannot ordinarily be photographed because they appear too small in the frame. Even common activities like threading a needle can make striking images. Photo: K. Bancroft.

Split Focus

There are special supplementary lenses that let you achieve close-up sharp focus of a foreground object without throwing the background out of focus. These lenses are split-focus, or bi-focus, attachments. They are simply half a supplementary lens; the other half is either plain glass or plastic, or an empty mount. You can place a split-focus attachment in front of the camera lens so that the close-up object can be at the left or right side of the frame, or at the top or bottom.

An unusual variation of the split-focus supplementary lens is the eccentric spot attachment. This device consists of a circular supplementary lens area located off-center within a clear field. It allows you to combine the sharp close-up of an object anywhere in the frame with a sharply defined background. With either the split-focus or the eccentric spot lens the close-up focus distance is determined by the power of the supplementary element. If you do not have a reflex-viewing camera, you can figure that distance by the method given on the opposite page.

There is also a close-up prism attachment—a two-faceted supplementary lens. It gives a double close-up image of a single subject.

4

Choosing Filters
for Picture Control

Altering images to create special effects is one of the two major aspects of using filters. The other is using filters to control the results you get on the film.

Control is sometimes a matter of adjusting the color balance of the light entering the lens so that the subject looks natural and realistic in the image. At other times it is a matter of creating subtle color emphasis that enhances the subject without making anything look special or unusual.

In black-and-white photography control with filters is often a matter of making sure that subject colors are translated into appropriate and effective shades of gray. This may be necessary simply for accuracy and visual clarity. Or it may be desired as a way to create graphic impact without sacrificing the power of realistic representation.

Filter control can also be a means of exposure control so that you can overcome bright light conditions to use the f-stop or shutter speed of your choice, in color or in black-and-white.

Many specific aspects of using filters for picture control are covered in Chapters 5 and 6. But there are important basic considerations that are the same for all filters. Those considerations are what this chapter is about. They include:

Choosing the right filter. There are hundreds of filters you might use. How do you begin to identify what kind of filter, and then which specific filter, will do the job you have in mind?

Exposing correctly. Filters absorb part of the light, reducing image brightness. Some absorb so little that they have no effect on exposure; others absorb enough light that you must adjust exposure to get proper results. How do you determine how much adjustment is required, and how do you make it?

Handling. Most filters are used in the image path. Scratches, dust, dirt—anything wrong with the filter—can affect the quality of the image. Keeping filters in good condition is extremely important.

A deep red filter absorbs blue light, darkening the sky. The smoke stands out vividly for a dramatic picture. Photo: J. Peppler.

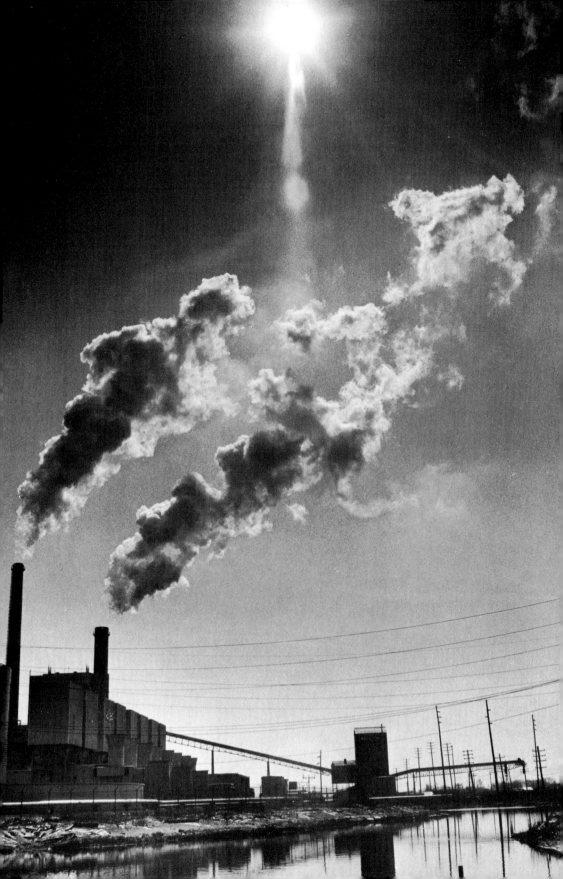

How to Choose a Filter

The first step in choosing the proper filter to do the job you have in mind is to decide what color or colors in the subject need to be changed in the final image to get the results you want. This requires careful looking at the subject, coupled with an understanding of how light causes us to see colors and how filters act to change colors.

In general terms, in black-and-white photography you can make a particular subject color look lighter or darker, while in color photography you can intensify a color, to make it more noticeable or vivid, or you can de-emphasize it and reduce its effect on the final image. The problem is knowing what filter to use.

To some extent you can see what a filter will do just by looking through it. But there is a right way and a wrong way to do that.

The wrong way is to hold the filter to your eye and stare continuously at the scene through it. Your eye quickly adjusts to the change; it cannot ignore the filter color, and you visually forget the original appearance of the subject. Because your eye adapts involuntarily to the filter, it is hard for you to judge the true effect. In addition, a film emulsion responds differently than your eye does.

The right way is to look at the subject and to briefly move the filter into your field of view and out again, flipping it in and out several times. In this way you get repeated impressions of the subject with and without the filter. What you should look for is the general impression of which colors get lighter and which get darker as the filter moves into the field of view. If you are taking color pictures, look to see if the filter neutralizes or removes color tinges in key parts of the subject such as skin tones, or in white or light colored areas. This may be somewhat imprecise, but it is a handy way to quickly determine whether, say, a yellow or an orange filter will do the job you want.

Of course you may not always have time to check the subject through a variety of filters, and you probably do not want to carry everything you own wherever you go. You may need or want to plan ahead what filters to use in various situations. You can make quite precise filter selections if you know some basic things about light and color—the things that are explained on the following pages.

Examining a subject visually through a filter, as described on the opposite page, is suitable for black-and-white photography. The effects of filters used to obtain high quality results in color photography can really only be judged by practical tests. Use a color chart or objects that you can directly compare with your processed slides or prints. As you can see in these test shots, the colors in the top picture are gray and dull. The lower version reveals the effect of corrective filtration to more closely match the color balance of the light to that of the film used. Photos: C.M. Fitch.

A Little Color Theory

The colors you see, and that register on film, are mixtures of various wavelengths. When sorted out in order, the wavelengths of light form a continuous spectrum from deep red to deep blue and violet.

To understand color vision and color photography, think of the spectrum as being simplified into three major bands of color: red, green, and blue wavelengths. The retina of the human eye contains cells, called cones, which respond to these colors. Some cones are sensitive to red wavelengths, others to blue wavelengths, and still others to green wavelengths.

When you see a color, the cones are stimulated by a particular mix of red, green, and blue wavelengths in the light striking your retinas. Because all color sensations can be created this way, red, green, and blue are the building blocks—the *primary colors* of light.

Color films have three emulsion layers, each sensitive to one of the primary colors. So, like the cones of the eye, color film responds to the various proportions of red, green, and blue in the light forming the image that falls on it. You can control the color balance of an image by using filters to absorb some or all of the red, green, or blue wavelengths in the light.

Color Mixing. The key to choosing filters for color control is knowing how primary colors of light combine to produce other colors. The accompanying triangle diagram will help you to visualize the fundamentals of color mixing.

1. An equal mix of all three primaries is seen and photographs as white:

 Red + Green + Blue = White

2. An equal mix of just two primaries produces a secondary color:

Primary Mix		Secondary Color
Red + Blue	=	Magenta
Blue + Green	=	Cyan
Green + Red	=	Yellow

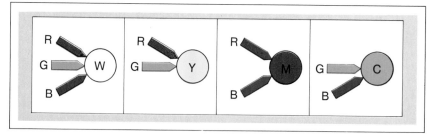

Equal proportions of primary colors of light create white or secondary colors of light; unequal mixes produce other colors. To plan filter use, visualize subject colors as a mix of light primaries.

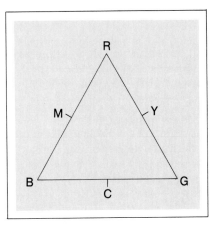

The color triangle summarizes both light and filter principles. A secondary and its related colors are made up of the primaries at each end of its triangle leg. A filter passes all colors on its half of the triangle, but blocks colors on the opposite half. Colors directly opposite one another are complementary pairs.

Because each secondary color is composed of equal proportions of two primaries, a complete set of primaries is formed when a secondary is matched with the primary directly opposite it on the color triangle. These matched-up sets are called *complementary pairs.* They are:

Red and Cyan (green + blue)
Green and Magenta (blue + red)
Blue and Yellow (red + green)

Complementary pairs are important because they are the basis of choosing the proper filter to control any color in the subject. The rule is simply this: *A filter absorbs light of its complementary color.* So, to control a color, choose a filter of the opposite color. To reduce reddishness, use a cyan filter; to cut down yellow, use a blue filter; and so on. How much you reduce a color depends on the strength (density) of the filter you use.

In black-and-white photography major changes in the light are usually required to produce a visible effect on the film, so it is common to use primary color filters. In color photography much more subtle control is required. In this case secondary color filters (cyan, magenta, and yellow) are the most useful, because each absorbs just one primary color. This gives you great selectivity in controlling the color balance of the light forming the image.

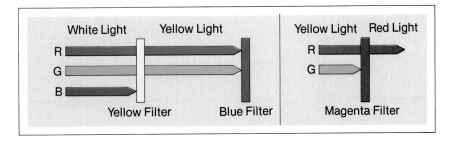

The color you see in a filter is a mix of primary colors of light. The filter passes those colors and absorbs all others. Filter density determines how much of a blocked color is absorbed.

Exposure with Filters

Filters absorb or block some percentage of the image-forming light. To compensate for the lost light, exposure through a filter usually must be increased, otherwise the final slide or print will look too dark.

Some very lightly colored filters absorb so little light that no exposure compensation is required. In many other cases the built-in metering systems in most single-lens reflex cameras will provide accurate exposures with readings taken through a filter placed in front of the lens. This is true for most of the filters used for color photography, and for ultraviolet (haze) and yellow filters used in black-and-white photography. It is also possible to take accurate readings through these filters by holding them over the light-sensitive cell of a hand-held meter before mounting the filter on the lens.

It usually is not possible to take accurate exposure readings through strongly colored filters such as the red, green, orange, and blue filters used with black-and-white films. In these cases you can determine correct exposure by taking a reading of the subject without the filter, and then adjusting the meter-indicated exposure to the degree called for by the *filter factor*.

Filter Factors. A filter factor is a number that tells you how much to increase exposure to compensate for the light-absorbing power of the filter. The factor for a black-and-white filter is often marked in one corner, or on the edge of the mounting ring. Filters for color photography are seldom marked with factors, primarily because most have only a slight to moderate exposure effect. The factors for filters that do require exposure adjustment are given when appropriate in this book. If you do not know the factor for a filter, you can determine it quite accurately with the simple test described on the following pages.

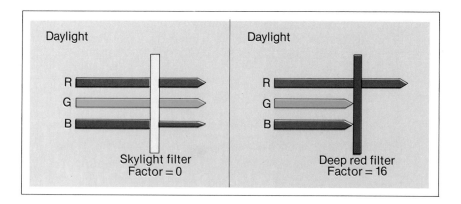

A filter's factor depends on its degree of absorption. (Left) A skylight filter for color film absorbs only a small amount of blue light; so much is passed that no exposure compensation is required. (Right) A deep red filter for black-and-white film absorbs so much light it requires four stops (16 ×) additional exposure.

Exposure Adjustment. To use a filter factor, do the following.

1. Take an exposure reading *without* the filter in the path of the meter.
2. Determine the change required by the filter factor:

Factor	Step/Stop Change	Factor	Step/Stop Change
1.5	½	7–9	3
2	1	10–13	3½
3	1½	14–18	4
4	2	20–27	4½
5–6	2½	30–35	5

3. Either open the lens aperture that many *f*-stops from the meter-indicated setting, or change the shutter speed setting that many steps slower.

For example, if the original meter reading is $f/11$ at 1/125 sec., and the filter factor is 4, either set the lens at $f/5.6$ (two stops wider than $f/11$) or set the shutter to 1/30 sec. (two steps slower than 1/125).

If you wish, you can divide the adjustment between the aperture and the shutter. For example, a filter factor of 8 requires a 3-stop/step change. You could open the lens two stops, and set the shutter one step slower.

If you are making a time exposure, multiply the meter-indicated time by the filter factor. If the meter says two seconds, and the filter factor is 5, the basic corrected exposure is 10 seconds. (Usually additional compensation is required with time exposures. See your film instruction sheet about correcting for the "reciprocity effect.")

If you are combining two or more filters, *multiply* their factors together and make proper compensation for the result. For example, a polarizer (2.5 factor) and a 6× blue filter have a combined factor of 15 ($2.5 \times 6 = 15$).

Film Speed and Filter Factors. Another way to determine exposure with a filter is to set your meter to a film speed that takes the filter factor into account. To find the adjusted speed, simply divide the normal film speed (ISO/ASA rating, or your personal exposure index) by the filter factor. Set the meter for the new speed. For example if the normal film speed is 320 and you are using a filter with a factor of 8×, set the meter to 40 ($320 \div 8 = 40$).

Now you can take readings directly from the subject (not through the filter, of course) and use the meter-indicated exposure settings. This method is quite useful with hand-held meters, but not so useful with built-in camera meters because you would have to stop and take the filter off the lens each time you wanted to take a new reading. Remember to reset the meter to the normal film speed when you are no longer using that filter.

Technique Tip: Testing for a Filter Factor

The factor marked on a filter can only represent an average correction for typical subjects under typical conditions. In some cases the actual, or effective, factor will be different for daylight or electronic flash than for tungsten light. Or it may differ according to the kind of film you are using. The best way to determine an accurate filter factor is to make a practical photographic test. These are the steps:

1. Take a meter reading from a fully-lighted subject to determine normal exposure, based on the usual speed at which you rate the film. Make a reflected-light meter reading from the most important subject area, or from an 18-percent reflectance gray card (Kodak neutral test card). Or take an incident-light meter reading from the subject position with the meter cell aimed toward the camera position.

2. Make an exposure without the filter. Use either $f/11$ or $f/16$ and the shutter speed called for by the meter reading.

3. Put the filter in front of the lens and make a series of increasing exposures. Use the same shutter speed, but open the lens one-half stop each time. Make a note of the f-stop setting used for each exposure. Most 35mm camera lenses have intermediate click-stop positions between the marked f-numbers. If your lens does not have click stops, simply set it as accurately as possible midway between the marked stops.

4. Examine the processed film to find which exposure made through the filter most nearly matches the unfiltered exposure. To determine the filter factor, count the number of stops difference between the apertures at which these two exposures were made, and consult the preceding page.

 With color slide film, make the comparison by projecting the slides. With negative films it is best to compare prints. First make the best possible straight print (with no dodging or burning-in) from the unfiltered negative. Then print the most likely filtered negatives using exactly the same f-stop and exposure time to find results that most closely match the unfiltered print.

Exposure Control: Neutral Density Filters

Instead of using filters to control color, you can use them to control exposure by limiting *how much* light gets to the film. You might want to do this in order to use a large lens aperture for a shallow zone of sharpness (called "depth of field") in the picture, or to use a slow shutter speed with a brightly lighted subject.

The filters used for this purpose are colorless or gray *neutral density* filters. You can use them alone or in combination with colored filters. Because they do not change the color composition of the light when used alone, exposure readings taken through these filters are entirely accurate.

Some manufacturers identify their neutral density filters with the exposure factor. For example, ND2, ND4, ND8, designate filters that require one, two, and three stops exposure compensation, respectively. Other manufacturers give the actual density, which relates to light and exposure as follows.

Filter Density	Reduces Light	Equivalent Factor	Filter Density	Reduces Light	Equivalent Factor
0.1	1/3 stop	1.25	0.6	2 stops	4
0.2	2/3	1.5	0.7	2 1/3	5
0.3	1	2	0.8	2 2/3	6
0.4	1 1/3	2.5	0.9	3	8
0.5	1 2/3	3	1.0	3 1/3	10

Higher density filters are available. Each 0.3 increase in density reduces the light by the equivalent of one *f*-stop. You also can combine these filters to get a desired strength; the densities add together. For example, an 0.2 filter plus an 0.3 filter is equivalent to an 0.5 filter.

The 0.1 and 0.2 filters permit precise exposure control in one-third stop steps. They reduce the light one-third and two-thirds of a stop, respectively. To get an exposure *increase* of only one-third of a stop, open the lens one full *f*-stop and use an 0.2ND filter. For a two-thirds stop increase use an 0.1ND filter instead.

To make the tiger lily stand out clearly in a scene like this, an out-of-focus background is desirable. For the shallowest depth of field, use a neutral density filter that allows you to open your lens to the maxium aperture.

Filter Handling, Care, and Cleaning

Filters used in front of a camera or enlarger lens become part of the image-making optical system. You must treat them with care, or the quality of your images is likely to suffer. Filters not used in the image-forming path—for example, those used in front of light sources—cannot affect image qualities such as sharpness. For this reason they are often handled rather carelessly. However, to extend their working life, they too should be treated with care.

Think of your filters as lenses and handle them as carefully. Touch square filters only by the edges, or in the corners, which will never come into the lens field of view. Handle circular filters only by their mounting rings. Use gelatin filters only in metal or cardboard frames to protect them from damage.

Keep glass and plastic filters in protective cases or containers. If you use individual pouches or cases, select them with care. Many fit so tightly that you can't remove a filter without getting your fingers all over it. Remember that these containers can collect dust and dirt over a period of time. It's a good idea to wipe or brush them out every few months.

Keep gelatin filters between two layers of tissue when not in use, either the tissue in which they were originally packaged or a piece of lens tissue. Do not use facial tissue because it is loaded with lint, and do not use paper towels or similar materials which may be harsh enough to scratch the filter material.

When purchasing a filter case, check to make sure that there are individual pouches which adequately protect attachments from rubbing against each other.

(Left) A light brushing with a soft, lint-free tissue is all that is usually required to remove dust. (Right) Specially formulated lens cleaning fluid is available at most photo stores. Use it sparingly and wipe carefully.

Cleaning. The best way to clean a filter is simply to blow the dust or dirt off the surfaces. Use your breath or a can of compressed air or inert gas such as that sold for darkroom use. If blowing won't do the job, use a very soft lens cleaning brush. You can improvise a brush by rolling a piece of lens tissue into a loose cylinder about the diameter of a pencil, and tearing it in half to get two pieces with torn, brush-like ends. Use the brush or lens tissue very gently.

To remove surface film from a glass or plastic filter, hold it close to your mouth and breathe on it to create slight condensation, then gently wipe the surface clean with a piece of lens tissue. Do not scrub the surface or polish it briskly. And do not use silicone-treated tissue sold for cleaning eyeglasses; it can damage photographic filters and lens coatings.

Use lens cleaning fluid only as a last resort, and never on gelatin filters. It may be possible to put a drop or two on the surface of a glass or plastic filter and then wipe the surface clean with a piece of lens tissue. However, it is far better to dampen the tissue first with the fluid.

Filters as Lens Protectors. It is often recommended that you keep a filter in front of your lens at all times to protect the front lens element. The idea is that if damage occurs, it is cheaper to replace a filter than a lens. However, a constantly exposed filter can only collect dust, dirt, fingermarks, and scratches—and keep them in the optical path. The only practical way to follow this advice would be to keep some filter in front of the lens, but take it off and replace it with a clean, perfect filter each time you want to take a picture. It's simpler to use a lens cap, and it's cheaper.

5

Control in Color Photography

By far the most important use of filters is for color photography. This is because color photographic materials reveal even slight color variations with great clarity, far more so than black-and-white materials. Color films and printing papers are made for use with specific kinds of light. Some emulsions will give proper results with one of two kinds of tungsten light, other emulsions are designed for use with daylight and electronic flash. The differences in emulsion sensitivity are related to the different color content in these kinds of light.

Color Balance. The proportions of red, green, and blue wavelengths in a particular illumination is called its color balance. Color films are made to give natural rendition when exposed to light of a particular color balance. However, sometimes it is necessary to use a film with an "improper" light source, one that does not match the color balance of the film. In other cases a subject may reflect various colors of light unevenly.

Control in color photography consists of using filters to adjust the light from the subject so that it registers in the desired way on the film. You may want to get the truest possible record of the actual subject colors, or you may want to shift the colors drastically for startling, unrealistic, or imaginative visual effects. In either case you must adjust the color balance of the light that comes through the lens—you can't change the color balance or color response of the film emulsion.

Color balance can be accurately specified by means of a system called *color temperature*. When you use filters to control light for color photography, you are actually raising or lowering the color temperature of the light. In some cases there are standard filters you can use to achieve the necessary change. In other cases you must determine which filter combinations will shift the color temperature to produce the results you want. In any event, understanding color temperature will help you understand the creative control of color photography.

Even slight color tinges may be noticeable in white objects and skin tones. Various color control filters will help you get the cleanest rendition of subject colors.

Color Temperature

When a material is heated, it eventually gets so hot that it begins to glow—first dull red, then cherry red, orange, yellow, blue-white, and white, as the temperature rises. The color temperature system is based on measuring how hot a standard black material is when it gives off light of a particular color or wavelength mixture. The temperature is measured on the Kelvin (K) scale. When we say that the light from the sun, a flash unit, or a tungsten bulb is 5000K, we mean that it has the same color balance as the light given off when the standard black material gets that hot.

Light of a low color temperature is weak in blue wavelengths and therefore looks red or yellowish. Light of higher color temperatures has more blue and looks more and more white as the temperature increases. In photography we are primarily concerned with three color temperatures: 5500K, 3200K, and 3400K.

The color temperature of average noontime daylight is 5500K. This is also the average color temperature of light produced by electronic flash units. Daylight-type color films are balanced to give correct color response with 5500K light.

Virtually all tungsten-type ("indoor") color films for still photography are balanced for 3200K light. These are also called Type B films.

At present only one film, Kodachrome 40 film, has a Type A emulsion, balanced for 3400K light. Photolamps of 500 watts produce 3400K light.

Not all light sources match these color temperatures, as you can see in the accompanying table. To get proper color rendition, you often must use filters to adjust the color temperature of the image-forming light to match the color balance of the film you are using in the camera.

Decamireds. Filters do not have color temperature ratings. However, when the color temperature of light is expressed as a *decamired value,* filters can be rated by how much they will change or shift that value.

The decamired value (DMV) is obtained this way:

$$DMV = 100,000 \div \text{Color temperature (in K)}$$

Decamired values for various light sources are included in the color temperature table. (A related rating, the mired value, is simply the DMV multiplied by ten.)

Reddish or amber filters have positive decamired shift values. That is, they will raise the decamired value of light passing through them. Bluish filters have negative shift values and will lower the decamired value of light. The method of using decamired values to select filters for color control is explained later in this chapter. Some color temperature meters—a very specialized kind of light meter—indicate directly the DM filter values needed to match the light to a particular type of color film.

COLOR TEMPERATURE OF COMMON LIGHT SOURCES

Source	Color Temperature (Kelvin)	Decamired Value
Open blue sky	12000–18000	8–6
Direct sun, noon average	5400–5500	19–18
Flashcube, magicube, flipflash	4950	20
Clear wire-filled flashbulbs	3800–4200	26–24
500-watt photoflood	3400	29
500-watt (3200K) photolamp	3200	31
200-watt household bulb	2980	34
100-watt household bulb	2775–2900	36–35
75-watt household bulb	2820	35
40-watt household bulb	2650	38
Candlelight	1885–1930	53–52

When photographing a scene illuminated by light sources of different color temperatures, some of the objects will not render naturally. This picture clearly reveals how warm-gold tungsten light is in comparison to the greater bluishness of daylight. Photo: T. Tracy.

Conversion Filters—Correcting Mismatch

The strongest filters commonly used to control color photography are *conversion filters*. They are used to correct a gross mismatch between the color temperature of the light and the color balance of the film.

A mismatch creates problems because tungsten and other light of low color temperature is deficient in blue wavelengths. Tungsten-type color films have extra blue sensitivity to compensate for the characteristics of this kind of light. But when you use these films with daylight or electronic flash—which have a normal amount of blue—that extra blue sensitivity distorts the image colors. Warm colors are neutralized toward white, blues are overemphasized, and very light colors and white take on bluish tinges.

Daylight-type color films have equal red, green, and blue sensitivity. When used with blue-deficient tungsten light they produce images with an overall red-gold cast.

Conversion filters change the light so that the image is recorded with natural subject colors even though it is the "wrong" light for the film. There are various designations for these filters; the most common are No. 85 (A, B, C, D) and No. 80 (A, B, C, D). Equivalent designations in other systems are given in the Appendix.

A yellowish or amber No. 85-series filter will absorb some blue wavelengths, so you can use a tungsten-type film in daylight. A bluish No. 80-series filter absorbs red and green wavelengths to adjust tungsten light to a daylight-type film balance. The accompanying table gives some specific recommendations. Be sure to check your film instruction sheet for other recommendations if you plan to mismatch a film and light source. Conversions filters are available almost everywhere photographic equipment and supplies are sold.

COLOR CONVERSION
Use the indicated filter to match the light to
the color balance of the film.

Film Type	Light Source		
	Daylight; Electronic Flash	Tungsten 3400K	Tungsten 3200K
Daylight	None	No. 80B	No. 80A
Tungsten (Type B, 3200K)	No. 85B	No. 81A	None
Type A (3400K)	No. 85	None	No. 82A

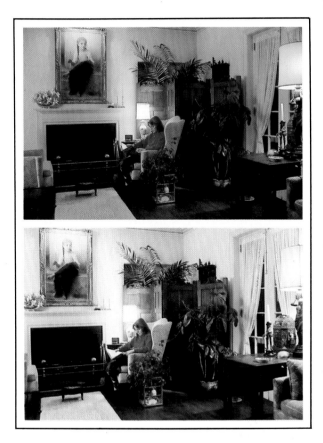

(Above) The warm gold tones produced by tungsten light on daylight type film are often quite pleasing even though not accurate. (Below) Proper conversion filtration produces much truer colors with the same light and film combination.

Exposure with Conversion Filters. You generally can rely on exposure readings taken through conversion filters to give good results. However, if you wish to make exposure corrections yourself, take a reading without the filter in place and then adjust the camera settings as follows. You can either open the lens aperture the indicated number of stops, or can use the filter factor to change the shutter speed, as explained in Chapter 4.

CONVERSION FILTER EXPOSURE CORRECTION

Filter No.	Exposure Increase in Stops	Equivalent Factor
80A	2	4×
80B	1½	3.5×
85	½	1.5×
85B	½	1.5×

Light-Balancing Filters—Small Shifts

Like conversion filters, *light-balancing filters* affect more than one color or group of wavelengths to change the color temperature of light. However, light-balancing filters make much smaller changes in the composition of the light.

Light-balancing filters are available in a bluish No. 82 series to raise color temperature, and in a yellowish No. 81 series to lower color temperature. You would need this kind of filter to match household tungsten light to a tungsten (3200K) type film, or to match 3400K photolamps to the same film. You would also need a light-balancing filter to match electronic flash with a daylight-type color film if the flash output was somewhat above or below 5500K.

How to Match Light to Film. You can choose the proper filter to correct almost any light-and-film mismatch by working with decamired values. Here are the steps:

1. Determine the decamired value (DMV) of the light source; see the table given earlier in this chapter.
2. Compare that with the decamired value of the light for which your film is balanced:
 Daylight-type film: DMV 18
 Tungsten (3200K) film: DMV 31
 Type A (3400K) film: DMV 29

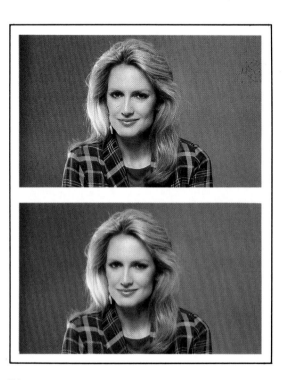

Although they are noticeably different colors in these two pictures, either background might be acceptable. The need for color adjustment is revealed by the subtle differences in skin tone and costume colors. The picture above has enough mismatch between film and light source to give things a bluish cast. The picture below used some yellow-amber filtration to correct the situation.

3. Now figure how much positive (+) or negative (−) shift value you need to match the light value to the film value. For example, if the light DMV is 17 and the film DMV is 31, you will need a filter with a +14 decamired shift value to raise the light to match the film. But if the light DMV is 29 and the film DMV is 18, you will need a filter with a −11 decamired shift value to lower the light to the film value.
4. Consult the accompanying table and select the filter with the closest shift value. You can combine filters if necessary, their shift values add together. For example, a −8 and a −11 filter have a combined decamired shift value of −19.

DECAMIRED SHIFT VALUES OF CONVERSION AND LIGHT-BALANCING FILTERS

Filter Number	Color	Decamired Shift Value	Typical Color Temperature Conversion, in Kelvin
80A	Blue	−13	3200 to 5500
80B	Blue	−11	3400 to 5500
80C	Blue	−8	3800 to 5500
80D	Blue	−6	4200 to 5500
82C	Bluish	−4.5	2800 to 3200 2950 to 3400
82B	Bluish	−3	2900 to 3200 3060 to 3400
82A	Bluish	−2	3000 to 3200 3180 to 3400
82	Bluish	−1	3100 to 3200 3290 to 3400
81	Yellowish	+1	3300 to 3200 3510 to 3400
81A	Yellowish	+2	3400 to 3200 3630 to 3400
81B	Yellowish	+3	3500 to 3200 3740 to 3400
81C	Yellowish	+3.5	3600 to 3200 3850 to 3400
81D	Yellowish	+4	3700 to 3200 3970 to 3400
81EF	Yellowish	+5	3850 to 3200 4140 to 3400
85C	Amber	+8	5500 to 3800
85	Amber	+11	5500 to 3400
85B	Amber	+13	5500 to 3200

Color Compensating Filters—Fine-Tuning Your Control

For the most subtle control of individual colors you can use color compensating (CC) filters. These filters are available in various densities from very slight to moderate strength, and in six basic control colors: primary red, green and blue, and secondary or complementary cyan, magenta, and yellow.

CC filters are your key to eliminating slight color casts or tinges. For example, a red or magenta CC filter can neutralize the greenish tinge of light reflected onto a subject from nearby foliage. A cyan CC filter can correct the reddishness of a subject close to a red brick wall.

You can also use CC filters to add a bit of unobtrusive color so that light-colored skin tones photographed on an overcast day do not look pale and lifeless, or so that muted colors of an object do not look drab.

CC filters are available in densities from 0.025 or 0.05 up to 0.50. You would seldom want higher densities for control purposes, but you might want them to add noticeable color to a picture. You can combine two filters of the same color to do this; their densities simply add together. The filters are usually identified by "CC," the density, and a letter indicating the filter color—for example, CC20Y, CC40M, CC05B, and so on. Often the CC prefix is dropped: 10C, 30G, 50R.

Achieving CC Control. The key to using CC filters for effective control in your pictures is to identify clearly what color change you want to make. Do you want to reduce the strength of a color in the subject, or do you want to add a color effect? You can do either, but you must keep in mind that filters do only one thing—they *absorb* certain colors.

To remove a particular color tinge, you must use a filter of the opposite, complementary, color. That is, to remove reddishness, use a cyan filter. Often a very slight density, 10 or 20, will do because you do not want to remove a color entirely (that would distort everything else), but only want to eliminate the excess that is causing an unwanted color cast.

To add or emphasize a color, use a filter of that same color. In fact, this does not add color, it reduces the other colors so that the one you care about stands out more. If you want to add warmth to a scene, use a red CC filter. It absorbs green and blue (or cyan) so that the amount of red in the light from the subject is more apparent. You will need a density of 20 to 40 to effectively add some color to a subject.

The accompanying table reduces CC filter choice to its simplest terms. You may also want to review "A Little Color Theory" in Chapter 4 if you are doubtful about identifying a complementary color.

The color cast you see on the opposite page, left, can be reduced or eliminated with CC filtration of the opposite color. Compare it to the picture on the right. Sometimes you may wish to "overcorrect" in order to add a warm color tinge to the subject; that is simply a matter of using greater density of the desired color.

Correct Copies. You can also use CC filters to adjust and correct colors when you make duplicate color slides or copy color prints. The principles of choosing which filter color to use are the same. You can estimate how much density to use by viewing the image being copied through various filters, flicking them in and out of your line of sight to compare the filtered and unfiltered views.

Accurate estimating is not easy at first, so make additional copies through more and less density than the amount you first choose. It will be good to make various exposures through each filter, too. It is difficult to predict what kind of contrast and color density will project the truest image in a color slide.

CHOOSING CC FILTERS FOR COLOR CONTROL

Use This Filter	To Subtract	or	To Add
Cyan	Red		Cyan (Blue + Green)
Magenta	Green		Magenta (Blue + Red)
Yellow	Blue		Yellow (Red + Green)
Red	Cyan		Red
Green	Magenta		Green
Blue	Yellow		Blue

Fluorescent Light and True Color

The sun, electronic flash units, and tungsten lamps all produce continuous-spectrum light. That is, the light is composed of wavelengths across the entire visible spectrum, without any significant peaks or gaps. Light from fluorescent tubes has a discontinuous spectrum. There are peaks or "spikes" of high output in narrow portions of the green and blue wavelength bands, and little output in the red.

The eye cannot discern these differences. Fluorescent light looks more or less white, and subject colors look relatively normal. Color films can detect the uneven wavelength composition of fluorescent light, and they record it. As a result, pictures have an unnatural looking greenish, or green-blue, tone. If a picture shows people, or items of food, the greenishness can be quite unpleasing.

Fluorescent Light Filters. There are correction filters especially designed to help you achieve more natural looking color pictures with fluorescent light. Their designations vary, but the following filters are available from various manufacturers:

- FL-D—for daylight-type films with mixed fluorescent light (various kinds of tubes).
- FL-B—for tungsten-type (3200K, Type B) films with mixed fluorescent light.
- FL-DAY—for daylight-type film with light from "daylight" fluorescent tubes.
- FL-W—for daylight-type film with light from "warm white" fluorescent tubes.

You also can try a CC30M (magenta) filter with daylight-type films, or a CC40R (red) filter with tungsten-type films with mixed fluorescent light. They will give some correction, but not necessarily the best possible results.

A color photograph made by fluorescent light without filter correction has an overall greenish cast. Photo: D. Mansell.

Haze in Color Photographs

When you look at distant scenes, details are often obscured and colors neutralized by haze. Haze may be smoke or fog, pollution particles, dust, scattered light, glare, and reflections. In color photographs this visible haze is recorded and looks normal. In addition, color films record an invisible aspect of haze which makes distant things look veiled-over in blue.

The excess bluishness in outdoor landscapes is caused by ultraviolet wavelengths scattered in the atmosphere. Sunlight is rich in ultraviolet. Although the eye cannot see these wavelengths, film can, and it is the blue-sensitive layer of color film that records the extra exposure.

To overcome this bluishness, use a skylight (No. 1A) filter, or other UV-absorbing filter. The skylight filter absorbs the wavelength range most widely scattered in the atmosphere. The more distant the scene, the greater the amount of scattering, and therefore the more effective the filter. In addition, the faint pink color of the skylight filter absorbs a small amount of visible blue light. This makes it useful also to eliminate bluishness common to subjects in open shade, under a blue sky (but not in the direct sun), in the open on an overcast day, or in light reflected from snow, sand, or water.

The skylight filter absorbs so little light that you can use it with no exposure compensation. For increased ultraviolet and blue absorption, you can use very pale yellow filters, such as CC10Y or CC20Y, or filter Nos. 2A through 2E. As blue absorption increases, you will get greater haze penetration, and nearby subjects will look a bit warmer. However, these filters are not strong enough to give a picture a yellowish cast.

The foreground foliage is well defined, naturally rendered and richly saturated. The distant background, affected by atmospheric haze, is bluish and its color desaturated; a haze-reducing filter is needed.

Glare, Reflections, and Color Intensity

When light glares off a surface, you cannot see its color clearly, and neither can the camera. The intensity at the point of maximum reflection—the hot spot—creates a "dazzle" effect that wipes out color.

When reflected images mix with the main subject, a confusion of shapes and colors can occur.

When skylight is scattered in certain patterns, it washes out, or desaturates, the color of the sky and of distant objects.

These effects involve *polarized light.* All smooth, nonmetallic surfaces can cause polarization in reflected light. Such surfaces include water, glass, polished wood, glazed ceramics, leaves, the waxy skin of fruit, plastics, painted surfaces (unless a metallic-particle paint was used), and many more. Bare metallic surfaces such as automobile chrome do not polarize light. The degree of polarization that occurs depends on the smoothness of the surface and the angle at which light strikes it. Light from the open blue sky is also polarized; the maximum effect is at 90 degrees to the sun's direction.

The Polarizer. In ordinary situations not all the light is polarized by reflection. This gives you the choice of including all the light (polarized and unpolarized), reducing the effects of the polarized component, or even eliminating the polarized light completely. To do this you must use a special kind of filter called a *polarizer.*

To reduce or block polarized light, simply rotate the polarizer. You can see its effect as you look through the lens of a reflex camera. Or you can hold the polarizer in front of your eye and see the effect directly. When you like what you see, simply mount the polarizer on the lens in the same orientation. Most polarizers have an index mark on the rim or in one corner to help you keep track of their orientation. Think of the mark as being rotated to some position on a clock face and set it at the same "time" in front of the lens. You can go from minimum to maximum effect with no more than 90 degrees of rotation.

Results With a Polarizer. Removing reflected images is just one effect of a polarizer. It also can intensify subject colors by removing scattered polarized light that neutralizes or washes out colors. A polarizer absorbs ultraviolet wavelengths, so it helps to reduce some kinds of haze problems and clarifies distant objects. It can also increase the blue of open sky without changing other subject colors. To get the maximum effect, aim the camera at a right angle to the direction of the sunlight, and rotate the filter until you see the deepest blue. The effect is greatest high in the sky and decreases toward the horizon.

A polarizer has an exposure factor of $3\times$ to $4\times$, so you must increase exposure 1½ to 2 stops. If your camera has a meter system that reads the image from a fixed mirror or a beam splitter, you will need a circular polarizer. This is not necessarily circular in shape, but

refs to the structure of the polarizing material itself. Check this point in your camera instructions and at the photo store when you buy a polarizer.

You can combine a polarizer with other filters to control both color balance and polarized light, or you can combine it with almost all special-effect devices. A polarizer can also be used for black-and-white photography in exactly the same way as for color photography. It will reduce reflections and glare, and it can improve contrast much as it improves color intensity.

(Above) Adjusting a polarizer for complete elimination of highlights and reflections may dull colors and reduce visual interest. (Below) Moderate polarization can remove distracting glare or reflections without making a picture lifeless. Watch the effect carefully; you can see it directly through the polarizer when you shoot.

6

Black-and-White and Filters

While filters are a normal part of color photography, many photographers ignore their great value in black-and-white work. However, some of the most stunning black-and-white photographs have depended upon the skilled and expressive use of filters.

Perhaps filters are disregarded because black-and-white films are so easy to use. There are few problems that correspond to the need in color photography to convert light sources and adjust color balance simply to get acceptable results. In black-and-white photography you can use mixed light sources with great freedom and get excellent results.

There are two main uses for filters in black-and-white photography. The first is to control or improve image clarity by contrast control. Clarity is partly a matter of sharp focus, good composition, unconfusing backgrounds, and similar factors. But even more important is the basic factor of distinct tonal separation, and that is a matter of contrast. For example, if you exhibit a low-contrast print and a high-contrast print of the same subject, most people will say that the high-contrast print is sharper. That is because the greater tonal separation makes details more distinct and therefore easier to see. Often, a filter is the only way to achieve this kind of clarity.

The second major use of filters is to achieve accurate gray-tone translation of subject colors. We cannot directly see a subject in grays, we see the natural colors. We can easily spot variations from the actual subject in a color image, but we are much less sensitive to how accurately colors are represented by various shades of gray. Unless something is rendered quite a bit too light or too dark, we are not likely to notice. However, that is an important factor, because it directly affects the expressiveness of a black-and-white image.

Some uses for filters in black-and-white work are the same as in color work. These include haze penetration, reflection and glare control, and exposure control. This chapter tells you how to use filters effectively in black-and-white photography.

A polarizing filter will cut down glare in scenes likely to have brilliant reflections. Adding a colored filter may also improve contrast. Photo: H. Weber.

Contrast Control

For you to see something in a picture it must stand out clearly—it must contrast with its surroundings. This is as important for small details as it is for the main subject in a picture. In black-and-white photography this means that each thing you want to see must be a distinctly different shade of gray from the things immediately around it.

When you look at a subject in the camera viewfinder, you see a full-color image; many things are clearly visible because of their color differences. But if two different, overlapping colors translate into the same shade of gray, they will blend completely in your black-and-white picture. There will be no clear difference between the objects they represent. A more common occurence is that the two colors translate into different shades of gray, but those shades are closer to one another than your visual impression of the difference between the actual colors. The result is de-emphasis, a toning down of the distinction between them.

Contrast. The degree of difference between two gray shades is called contrast. If you divide the range from black to white into five equal steps, the difference or contrast between any two adjacent steps will be much greater—and more noticeable—than if you divide the same range into ten or twenty equal steps.

You can control overall contrast by your selection of a film and by the processing you give it. Slow-speed emulsions have higher inherent contrast than fast emulsions. Increased development produces increased contrast. However, these choices do not give you selective control over one subject color or another; only filters can do that.

The key to contrast control is the basic rule of filter use: In black-and-white photography, a filter makes objects of its own color look lighter, and objects of opposite colors look darker. It works this way: If you want to make a red tomato stand out more clearly from the green leaves and blue sky in a picture, use a red filter. The filter will transmit all of the red light from the tomato, but it will absorb some of the green and blue light, so the leaves and sky will expose the film less. In a print, the tomato will be just about the same shade of gray as it would be in a print from an unfiltered negative. However, it will *appear* lighter because the surrounding leaves and sky will be darker in the filtered shot. This is not something you can achieve by dodging or burning-in during printing, it is a difference you must create on the negative.

Effect of Filter Strength. The stronger (more deeply colored) the filter you use, the more pronounced the effect in the print. If you use a medium yellow filter to photograph the sky, it will produce a separation between clouds and sky that matches what your eye sees. If you

use a deep yellow filter instead, more blue will be absorbed, so the sky will be darker and the clouds will look whiter in a print. If you use a deep red filter, the sky will go almost black while the clouds remain fleecy white. Of course, this assumes that you adjust the exposure in each case to compensate for the amount of light absorbed by the filter.

The table and pictures on the following pages indicate many of the effects you can produce with various filters and daylighted subjects. The basic principles of contrast control also apply with artificial light, but they will not always be the same as with daylight because of the proportional lack of blue wavelengths in tungsten illumination. Some filters will have a stronger effect, others will have an unchanged or reduced effect. The simplest way to tell is to make some test exposures of the same subject in both kinds of light, with and without a filter.

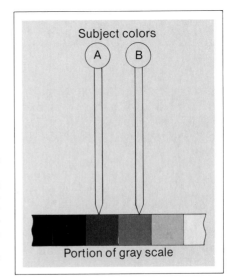

(Right) Two subject colors may photograph as adjacent shades of gray, or even the same shade. (Below left) Proper filter choice can increase the gray shade separation for greater contrast. (Below right) An alternate filter choice can reverse their gray shades without increased separation. Experience or tests will help you choose the right filter for each result.

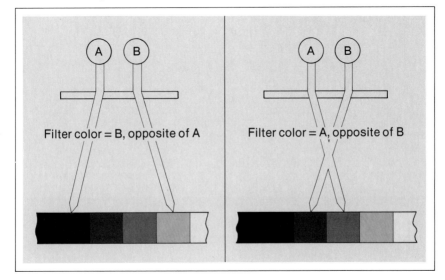

Filter Choice

Use the information given here to help you choose a filter for the kinds of results you want in a black-and-white picture. The table lists the effects of various filters with many kinds of subjects. The accompanying pictures show you what some of these effects actually look like.

FILTER SUGGESTIONS FOR BLACK-AND-WHITE FILMS AND DAYLIGHTED SUBJECTS

Subject	Filter	Effect
Blue sky	Yellow	Natural
	Deep yellow	Darkened
	Red	Very dramatic
	Deep red	Almost black
	Red plus Polarizer	Night effect
Water scenes under blue sky	Yellow	Natural
	Deep yellow	Water dark
Sunsets	None, or Yellow	Natural
	Deep yellow, or Red	Increased brilliance
Distant landscapes	Blue	Haze emphasized, added
	None	Slight haze added
	Yellow	Natural
	Deep yellow	Haze reduced somewhat
	Red, or Deep red	Increased haze reduction
People in close shots, against sky	Yellow-green, Yellow, or Polarizer	Natural
Flowers—blossoms and foliage	Yellow, or Yellow-green	Natural
Green foliage, nearby	Yellow, or Yellow-green	Natural
	Green	Light
Red, rust, orange, and similar colors	Red	Lighter, for detail
Dark blue, purple, and similar colors	Blue	Lighter, for detail
Light-colored building materials, fabrics, sand, snow, etc., under sunlight and blue sky	Yellow	Natural
	Deep yelow, or Red	Increased texture

Technique Tip: Seeing Black-and-White Contrast

There is a special filter that can virtually eliminate the effect of color when looking at a scene so you can see the basic contrast. It is a panchromatic viewing filter such as the Kodak Wratten No. 90 filter; its color is a dark gray-amber.

When you hold this filter close in front of one eye, it will show you the relative gray tones that daylighted subjects will have in a black-and-white print. The effect is a close approximation of the results you will obtain on a medium-speed panchromatic film.

Contrast control with filters in black-and-white. (Left) The subject colors. (Below) Filtered renditions. Top row, left to right: No filter; red filter; orange filter. Bottom row, left to right: Yellow filter; green filter; blue filter.

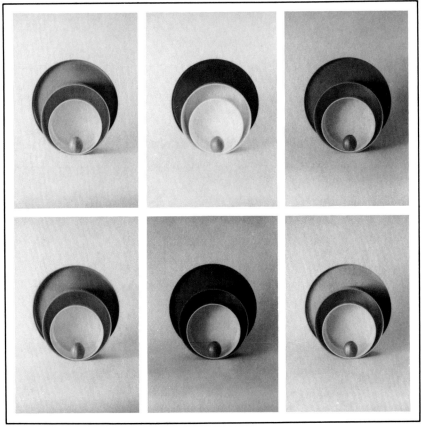

Controlling Haze, Reflections, and Exposure

Atmospheric or aerial haze causes a graying-out of distant tones and details in black-and-white pictures. The effect is caused by excess exposure from scattered light—especially blue wavelengths—and ultraviolet. A photograph may show more haze than the eye sees because film is ultraviolet-sensitive, while the eye is not.

The skylight and other UV-absorbing filters used to reduce the bluish appearance of haze in color pictures are not strong enough to be effective in black-and-white. To reduce and apparently penetrate haze, it is necessary to filter out both ultraviolet and some blue light. To do this, use the following filters:

- Medium Yellow—for results that match what the eye sees
- Deep Yellow—for moderate reduction of haze effects
- Red, or Deep Red—for maximum haze reduction
- Red filters will also significantly change the rendition of blue and green subject colors.

Some of the apparent haze in black-and-white pictures may be caused by polarized light from the sky or reflected by various objects in the scene. In that case a polarizer will significantly reduce haze. You also can use a polarizer in combination with another haze-reducing filter, but that has practical limitations: A polarizer plus a deep red filter requires a total compensation of five to five-and-a-half stops.

Reflections and Exposure Control. The polarizer is just as useful in black-and-white photography as it is in color work to control reflections and glare from smooth surfaces. Similarly, neutral density filters are equally useful for controlling the overall intensity of light entering the lens. Since these filters do not change the color balance of the light, they are used the same way for all kinds of photography. Methods of using a polarizer are explained in Chapter 5; neutral density filters are covered in Chapter 4.

A polarizer is essential to reduce reflections when shooting through glass. Aim at an angle to avoid seeing your own reflection. Photo: A. Moldvay.

Gray-Tone Correction

Panchromatic films do not have the same color response as the human eye. As a result, colors that are visually brilliant may seem less intense in an unfiltered black-and-white rendition. The eye is most sensitive to green wavelengths, while black-and-white emulsions have high sensitivity to blue and ultraviolet wavelengths.

To balance film response, most panchromatic films are given increased red response, on the assumption that most photographs will be taken under blue-rich daylight. This helps ensure that red objects will be recorded as strongly on the film as blue objects of the same visual brilliance. However, this can cause somewhat distorted rendition of colors when the subject is not in direct sun or is under blue-deficient tungsten light.

Two filters can correct the response of panchromatic films so that subject colors are translated into gray tones that match their visual brightness relationships. The filters are:

- Medium yellow—for subjects in daylight
- Yellow-green—for subjects in tungsten light

The effect is much less pronounced than that of filters used for overall contrast control, but there is a decided difference in the results.

A polarizer is not limited to reflection control. It is equally effective in black-and-white as in color for providing increased contrast in sunlighted subjects and skies. Photo: B. Bennett.

Black-and-White Filter Data

Most filters for black-and-white photography are strongly colored; the major exceptions are some light yellow and light red filters. In addition, most of the filters are primary colors: red, green, or blue. Of the secondary colors, only yellow is often used in black-and-white work; cyan and magenta are quite rare.

Filters for black-and-white photography are identified in various ways. The numbers in the accompanying table are just one widely used system. They are used here to help you relate the exposure data to equivalent filters identified by other systems.

Because most of these are stongly colored filters, exposure readings taken through them may not be accurate. It is better to take a reading with an in-camera meter without the filter in place and adjust the indicated exposure according to the table. Either multiply the shutter speed by the filter factor, or open the lens aperture the equivalent number of *f*-stops.

Filter Factors and Light Sources. Some filters have different exposure correction factors when used with daylight or electronic flash than when used with tungsten light. This is because these kinds of light do not have the same distribution of wavelengths. Daylight and electronic flash have essentially equal proportions of red, green, and blue wavelengths; tungsten light is deficient in blue wavelengths.

In general terms, red and orange filters have a higher factor when used with daylight than when used with tungsten illumination; bluish filters have a higher factor with tungsten light. Yellowish and green filters have essentially the same factor for both kinds of illumination.

You will encounter this difference in factors only in black-and-white photography. In color work you would seldom use the same moderately colored filters for tungsten light that you would use in daylight, so they usually have a single factor. Filters that you might use with both kinds of light are generally so lightly colored that the difference in the factor is not noticeable.

FILTER FACTORS AND *f*-STOP ADJUSTMENT*

Factor	Open lens	Factor	Open lens
1.5	½ stop	8	3 stops
2	1	12	3½
3	1½	16	4
4	2	20	4
5	2	24	4½
6	2½	40	5

*To nearest half-stop.

A colored filter absorbs a certain amount of light. If you do not compensate for the light loss, the results will be underexposure (left). By adjusting exposure as indicated by the filter factor, you will get normal looking results (right). Photo: K. Tweedy-Holmes.

FILTER DATA FOR BLACK-AND-WHITE FILMS

Filter No.	Color	Daylight	Tungsten
		Factor	
3	Light yellow	1.5	——
4	Yellow	1.5	1.5
6	Light yellow	1.5	1.5
8	Medium yellow	2	1.5
9	Deep yellow	2	1.5
11	Yellow-green	4	4
12	Deep yellow	2	1.5
13	Dark yellow-green	5	4
15	Deep yellow	2.5	1.5
21	Orange	4	2
23A	Light red	6	3
25	Red	8	5
29	Deep red	16	8
33	Magenta	24	12
34A	Violet	8	16
44	Cyan	8	8
47	Blue	6	12
47B	Deep blue	8	16
50	Deep blue	20	40
58	Green	6	6
61	Deep green	12	12
65	Deep bluish-green	16	16
Polarizer	Gray	2.5	2.5

Testing Filters for Black-and-White

There are two things you need to know about a filter for black-and-white photography: its true exposure factor and how it affects the gray tone rendition of various colors. A simple test can give you both kinds of information.

First find a set of color samples that you can photograph and keep for comparison. You might use a color chart from a paint store, a selection of colored paper samples from an art store, or the set of color reference patches that come with some photographic gray scales. Also get a good-sized medium-gray card. The Kodak 18-percent-reflectance neutral test card is considered a standard, but anything that approximates it will do.

Set up your color samples and gray card on a dark background; do not use a light color or white, because it may reflect contrast-reducing light toward the lens. If you wish, you can include a person in the test set-up to see how filters affect skin-tone rendition. For the most complete test, include both a light-skinned subject and a dark-skinned subject.

Because some filters produce different effects in daylight than they do in tungsten light, you may want to make separate tests with each kind of illumination. Make sure the test area is evenly lighted. Compare meter readings from the center and edges of the area to check that they are within one-third stop of one another.

A typical filter test set-up has a gray scale, neutral gray test cards, and sample color patches. To see how a filter will render flesh tones, include a person with the set-up. Photo: D. O'Neill.

Begin with an unfiltered exposure of the subject. Base your exposure on a reflected-light reading from the gray card, or an incident-light reading taken at the subject position with the meter cell pointed toward the camera location. Use a small *f*-stop for this exposure to give you plenty of leeway in changing the filtered exposures. Put a slip of paper in the picture with the notation "No Filter" and the *f*-stop used.

Follow the unfiltered exposure with a series of shots taken through the filter you want to test. Open the lens one stop for each successive exposure; with deep colored filters it may take three or four stops additional exposure, or more, to equal the unfiltered exposure. Be sure to include a note identifying the filter and the *f*-stop used for each shot. Process the film normally.

Evaluating the Test. You will need to make prints to see how the filter affects various colors. Proceed as follows:

1. Begin with the unfiltered exposure and make the best possible straight print (no burning-in, dodging, or other manipulation) on a normal grade of paper.
2. Use your eye to eliminate the filtered negatives that are obviously under- or overexposed (too light or too dark); pick out those that best match the unfiltered negative.
3. Make prints from each of those negatives *using the same f-stop and time* as for the test print from the unfiltered exposure (step 1).
4. When the prints are dry, compare them to find the filtered shot in which the gray card most closely matches its shade in the unfiltered shot. Filters do not affect neutral-gray rendition, so when the gray tone matches, the exposures were equal. The difference in *f*-stops between the two exposures will indicate the true factor of the filter, as follows:

Stops Difference	Factor	Stops Difference	Factor
1	2	4	16
2	4	5	32
3	8	6	64

To evaluate the filter's effect on the gray-tone rendition of colors, compare your color chart with the unfiltered print and the filtered print. Note which colors are rendered darker by the filter, which colors are rendered lighter, and which are unchanged.

Keep records of your results. This kind of test gives you the most valuable kind of information; it shows what your equipment and materials and your working methods will produce. That is far more meaningful than "universal" tables which must be based on average conditions and results if they are to be widely usable.

Infrared in Black-and-White

Infrared photography offers a wide range of expressive effects, according to the subject characteristics and the kind of filtration you use. There is one 35mm film suitable for this kind of photography, Kodak Highspeed Infrared film. It is sensitive to ultraviolet, visible blue and red, and infrared wavelengths. The lack of green sensitivity is seldom a drawback in exterior work because healthy foliage in sunlight reflects significant amounts of infrared.

If you use this film without a filter, the exposure effects of the visible wavelengths tend to overbalance and mask the infrared exposure. Filters which block some or all of the visible light make the infrared rendition increasingly clearer. In addition, the more infrared an object reflects or emits, the lighter it will be in the final print.

Typical results with infrared film in landscape photography show brilliant white clouds against an almost black sky, very light to white sunlit leaves and grass, and clear detail in the dark, shadowed sides of objects. Infrared also provides excellent haze penetration even at great distances. Architectural subjects photographed by a combination of infrared and visible light often have greater dimensional clarity than even strongly filtered panchromatic renditions. In fashion photography and portraiture, skin tones take on a pale, radiant, ghostlike quality when a large part of the visible light is filtered out.

Foliage appears light when photographed on infared film because it reflects a high percentage of the IR in daylight. Red filtration will emphasize the ghostlike quality skin tones produce on infrared film. Photos: D. O'Neill.

Infrared Filters and Exposure. Filters for infrared photography are either red or black. Red filters remove ultraviolet and blue wavelengths, and some orange-red wavelengths as their color deepens. The black filters look that way because they block ultraviolet and all visible wavelengths and transmit only infrared. They can be used over the lens, or in front of the light source if you want to take pictures unobserved in the dark.

It is not possible to predict the infrared output of light sources, nor the infrared reflectance and emission properties of various subjects. In addition, exposure meters do not read infrared. For these reasons exposure must be based upon testing and experience. Starting exposures for tests can be determined by an ordinary reflected-light reading of the subject with the meter set to the film speed given in the table. With an in-camera meter, take the reading before putting a filter on the lens.

FILTER AND EXPOSURE DATA FOR KODAK HIGHSPEED INFRARED FILM

Filter	Meter film speed setting for trial exposures	
	Daylight	*Tungsten*
None	80	200
No. 25, red No. 29, deep red No. 70, dark red No. 89B, opaque	50	125
No. 87, opaque No. 88A, opaque,	25	64
No. 87C, opaque	10	25

Guide Numbers for Trial Exposures* with Electronic Flash, and No. 87 Filter over Camera Lens

Unit output (ECPS/BCPS)	500	700	1000	1400	2000	2800	4000	5600
Guide No.	24	30	35	40	50	60	70	85

*To determine f-stop divide guide number by flash-to-subject distance in feet; set shutter at proper speed for electronic flash synchronization.

7

Special Applications

Filters offer solutions to many photographic problems. The specific techniques discussed here may be just what you need to get a certain kind of picture, or to improve the quality of your images.

Aerial Photography. Haze is the biggest problem in taking pictures from the air because there is a much greater volume of atmosphere between camera and subject than at ground level.

Black-and-white. Use a deep yellow filter below 1,500 meters (about 5,000 feet), and a red filter at higher altitudes. Also use a red filter at low altitudes if haze is particularly heavy. For maximum haze penetration use infrared-sensitive film and a No. 89B opaque filter, which is especially designed for aerial photography. Do not expect infrared penetration of smoke-filled haze common to industrial locations.

Color. Use at least a skylight filter in all cases. For haze, or at high altitudes, use a pale-yellow filter. Slightly stronger yellow filters will penetrate haze a bit more from higher altitudes, but also will warm the image somewhat.

Be careful about using a polarizer to shoot through aircraft windows. The windows are plastic, and the polarizer may reveal rainbow-colored stress patterns in the material. In addition, some window material is polarized and may interact with the camera filter to reduce the transmitted light.

Base aerial exposures on unfiltered meter readings taken at ground level or low altitudes; at high altitudes light scattered by haze will cause inaccurate readings. Be sure to add the required filter correction exposure when making camera settings, and bracket exposures by one or two *f*-stops. Give black-and-white films increased development to compensate for the reduction of contrast caused by distance and haze.

In aerial photography, use filters to get the best color rendition of the major areas of the scene. Sections in shadow, like those at the top of the picture, will be blue because they reflect only light from the open sky. If you try to correct for those areas, the colors of the directly sunlighted sections will be distorted. Photo M. Fairchild.

Special Applications

Architecture. In exterior photographs the major problems are to make the structure stand out in full three-dimensional volume from its surroundings, and to reveal the various planes and surface details. The first consideration is the light. So-called architectural lighting occurs when the sun falls on the surfaces facing the camera from about 45 degrees to one side and 45 degrees above.

In black-and-white photography use a deep-yellow filter to darken the sky and increase cloud detail for interest. Use a red filter for much darker skies to dramatize the structure and darken surrounding foliage. A green filter will have a similar sky effect without darkening grass and foliage. Excellent structural clarity is provided by infrared-sensitive film and a deep-yellow or a red filter, but the sky will be somewhat darkened and foliage lightened.

For architectural exteriors in color be sure to match the light to the film color balance. Keep in mind that the color of daylight is quite warm (reddish) early and late in the day; a slight amount of blue filtration will correct this. Try an 81B or 81C filter, or about CC30B (30M + 30C) color compensating filtration.

The shadow side of a building, or the entire building on a lightly overcast day, is often too blue in color pictures; an 81EF or 85C filter may be required for sufficient correction. A skylight filter is useful for fully lighted exteriors, but a polarizer will do a better job of darkening the sky and improving color saturation.

Inside, use filters to balance light sources and especially to counteract the problems of fluorescent light and color film. Use filters also to enhance the contrast or colors of significant areas and major details. For example, yellowish or reddish filtration will enhance the tone of natural wood panels and floors.

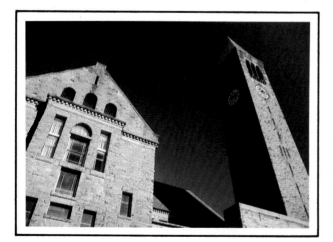

The dramatic angularity produced by a wide-angle lens was reinforced by using a polarizer to remove glare from the building surfaces and give the sky a deep color. Photo: P. Aitken.

The abstract qualities of much modern architecture can be emphasized by using high contrast to simplify shapes and planes of the subject. Here, a directly sunlighted building was photographed through a very deep red filter which blocked almost all the light from the green grass and blue sky so they would appear black in the final print. Photo: P. Eastway

Special Applications

Astrophotography. Photographs of the sun, moon, and stars are easy to take with long-focal-length lenses or with the camera coupled to a telescope. You can get large moon and sun images with a telephoto lens, and you can change them by using strong filters with color film if you wish. You can determine the size of either the sun or the moon in your picture this way: Diameter of image on film = Focal length of camera lens ÷ 110. Your answer will be in millimeters or inches, depending on how you express the lens focal length.

Pictures of the moon can show major surface features quite distinctly. However, moonlight scattered by the atmosphere may cause the sky areas around the moon to appear lighter than it does to the eye; this effect occurs during time exposures. With black-and-white film use a medium-yellow or deep-yellow filter to block the scattered light and show the moon in a deep-black sky.

An orange filter heightened the colors here. The sun's diameter on the film was just under 10mm, revealing that a 1000mm lens was used; see text for method of calculation. Photo: P. Bereswill.

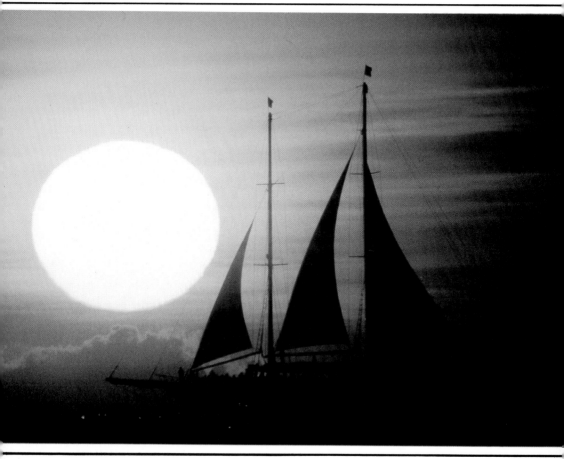

Sun pictures require caution! Direct sun can injure your eyes and damage your camera's shutter. The unobscured sun is so bright that there is no point trying to photograph it; the result would be a featureless disk. You can of course photograph the sun through an overcast sky or clouds as well as at sunrise and sunset, and you can photograph an eclipse. Use a 4.0 or a 5.0 neutral density (ND) filter for eclipse photography. Focus the camera at infinity. *Do not use ND filters to view an eclipse or to aim the camera.* Neutral density filters do not screen out the infrared wavelengths that can injure your eyes, even through a camera's reflex viewing system.

To make a direct-sun viewing filter, expose a medium speed (ISO 125) black-and-white film to white light outside the camera. Use 120-size or sheet film to get a large enough area to fully cover your eye or the front diameter of a camera lens. Develop the film for twice the normal time. Sandwich *two layers* of this maximum-density film and put them in place before looking toward the sun. Do not use color film; the dyes do not block infrared.

Beach and Snow Scenes. These situations have excessive brightness and contrast, glare from reflected light, and often excess bluishness in color pictures. Use a polarizer to reduce glare and darken extra-bright sky or use a graduated (sky) filter. Use neutral density filters to cope with the extra brightness when you are using a fast film; your lens may not stop down far enough without them.

Ultraviolet occurs in abundance in these types of scenes. Use at least a medium-yellow filter with black-and-white film; a deep-yellow filter will provide increased sky-snow separation. For color use a skylight filter, or a very pale yellow filter to overcome both ultraviolet and some visible bluishness. Shadows in snow scenes appear blue because they are reflecting light almost exclusively from the open blue sky, while the sunlit snow areas are reflecting all wavelengths.

Even under daylight conditions, daylight type film may need some filtration for the most pleasing colors. (Left) No filter used. (Right) Skylight filter used.

Special Applications

Copying and Duplicating. Filters can greatly improve your results, whether you are copying paintings, printed reproductions, or photographic slides and prints.

Black-and-White. For colored originals use a yellow-green filter with tungsten light, or a medium-yellow filter with electronic flash, for the most accurate gray-tone translation. Or, use filters for contrast control to emphasize some colors and de-emphasize others, just as you would in photographing subjects directly.

To improve contrast in a yellowed or faded black-and-white or sepia-tone photograph, use a blue filter and panchromatic film. To reduce or eliminate stains use a filter of the same color as the stain, but deeper. For example, use a deep-yellow filter to eliminate light-yellow stains. Use a filter of an opposite color to darken an element. For example, use a red filter to strengthen blue pencil or ink notations on a document.

Color. Match the light source to the film color balance precisely. Make tests with a white or neutral-gray surface to discover any color tinging; you may need some ultraviolet filtration with electronic flash illumination.

Use CC filters to correct color rendition from slides and prints; they are essentially the same as full-color original subject. To avoid the contrast build-up common in slide copying, use the special slide duplicating films offered by some manufacturers.

Flat subjects, both black-and-white and color, require flat, even lighting. If necessary, surface glare can be controlled with polarizers, as follows. Use tungsten lights, one on each side of the print or painting, at equal distance. Place a large sheet of polarizing material in front of the lefthand light, and place a smooth, polished non-metallic object at the subject position—a white saucer with a glossy glaze is good for this purpose. Put a polarizer in front of the camera lens and rotate it until any glare on the saucer that you see through the viewfinder is eliminated. Turn off the left light, place a polarizing screen in front of the righthand light, and turn it on. Look through the viewfinder and rotate the screen at the right light until any glare again disappears; *do not* change the left screen or the lens polarizer positions.

Two lights at 45-degree angles provide even lighting of flat subjects. Use polarizing screens at the lights and camera lens for glare control if necessary.

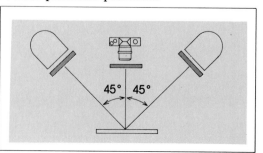

Flowers, Gardens, and Foliage. Follow the suggestions for color emphasis and control given in Chapters 4, 5, and 6. For overall garden or park views use as little filtration as possible, so you can close the lens down to a very small *f*-stop for maximum depth of field. For close views of blossom clusters or an individual bloom use neutral density filtration, if necessary, so you can open the lens to a large *f*-stop in order to throw distracting backgrounds out of focus.

Investigative Photography. Suitable combinations of filters, films, and light sources can record information that is invisible or undetectable to the eye. For surveillance photography in the dark use infrared-sensitive black-and-white film and electronic flash covered with a No. 87 opaque filter. To eliminate the slight red glow visible when looking directly at the flash, aim it to reflect its output off a nearby surface or use a No. 87C filter.

Some materials look identical but have different infrared reflectance—for example, ink used to alter a document or paints used to restore or overpaint a work of art. To detect such differences, use an infrared-rich light source (electronic flash or tungsten) and a No. 87 filter over the camera lens with black-and-white infrared-sensitive film. Use a medium-yellow filter with infrared color film. With thin materials also try shining the light through the subject from behind, with the appropriate filter on the camera lens, to detect differences in infrared transmission. Also see the section on ultraviolet photography later in this chapter.

Portraiture. In realistic color portraiture correcting the light so that skin tones have no color casts is very important. The problem is especially annoying in pictures taken in open shade or close to strongly colored objects that reflect some colored light. To counteract excess blue or green, use CC10R to CC30R filtration in open shade and foliage-rich locations. In general, it is better to make skin tones a bit too warm (red/yellow) than too cool (blue/green) if absolute color balance is not attainable.

A slight diffusing screen is widely used in photographing women because of its flattering effect in erasing fine lines and blending surface details of the skin. It is useful both in color and black-and-white. Moderate and heavy diffusion call attention to themselves and suggest that the picture is an artistic interpretation of the subject rather than a direct portrait.

In black-and-white a medium-orange filter will eliminate many kinds of skin blemishes such as freckles. A green or blue filter is sometimes used with panchromatic film to give the subject—usually a man —slightly darker skin tone by filtering out some of the red light. The convention is that this is a somewhat more virile rendition, but obviously other aspects of the individual are more important in suggesting rugged manliness.

In color portraiture and glamour photography like this, there is seldom anything more important than true rendition of skin tones. In colored surroundings, filtration will be necessary to remove color tinges caused by reflected light. Photo: J. Alexander

In black-and-white portraiture with diffuse natural light, some green or blue filtration may be helpful to achieve increased contrast. Experiment a bit under different kinds of light outdoors; too much filtration will produce a noticeably unnatural appearance.
Photo: K. Tweedy-Holmes.

Most telephoto catadioptric, or "mirror" lenses like the one used for this picture have a fixed maximum aperture. To reduce the image brightness for exposure control, it is common to use neutral density filters which are inserted in a slot at the rear of the lens—the front diameter is often too large for filters of practical size. Color control filters can be used in the same way with such lenses. Photo: K. Tweedy-Holmes.

Special Applications

Telephotography. In outdoor situations telephoto lenses sometimes give more blue in color pictures and less contrast in black-and-white than do normal and wide-angle lenses. In a few cases this may be due to differences in the kinds of glass and the number of elements used. The primary cause, however, is that the telephoto lens magnifies a small, more distant part of the scene, making the common effects of aerial haze more noticeable. The solution is simply to screen out ultraviolet and scattered blue. For color film use a very pale yellow filter; for black-and-white use a yellow or medium-yellow filter.

Ultraviolet Photography. Like infrared, ultraviolet wavelengths are invisible to the eye, but can be recorded by films. In fact, all emulsions are ultraviolet sensitive. Photographing ultraviolet visible fluorescence effects is covered in Chapter 2; here we are concerned with the invisible ultraviolet *reflectance* characteristics of materials. Investigative photography records these characteristics to discover forgeries, concealment, identicality, and other information, especially in examining documents.

For a light source use BLB (Black Light Blue) fluorescent tubes, or electronic flash units fitted with 18A filters which pass only ultraviolet wavelengths. Use ordinary light sources for setting up and focusing, but turn them off when taking meter readings and making exposures. Also use an 18A filter over the lens to exclude all visible light and transmit only the ultraviolet reflected by the subject. Use either color or black-and-white film, and establish a working film speed by practical test; exposures will be longer than those taken by visible light. With an accurate working film speed, incident-light readings with an 18A filter completely covering the meter cell will give useful exposure indications, but bracket exposures in any event.

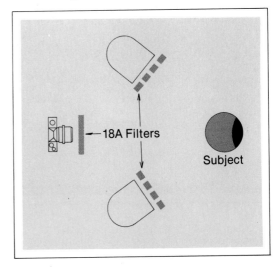

To record only ultraviolet, use a No. 18A filter over the lens. Also filter the light sources if they are not UV-only bulbs.

18A Filters

Subject

To obtain the most vivid colors underwater, use electronic flash. Its intense light at close range to the subject may make corrective filtration unnecessary. Photo: H. Taylor.

Special Applications

Underwater Photography. Water blocks red and green wavelengths from sunlight as depth increases, eventually leaving only blue light. Red disappears at about 6 meters (19½ ft.) depth in clear water, yellow at about 15 meters (45 ft.), and green at about 22 meters (72 ft.). Near the surface use CC10R to CC30R filtration with daylight-type color film to restore some of the lost red. Electronic flash can provide full color rendition at all depths, and a No. 81A filter improves the results.

In black-and-white use a red or orange filter to about 5 meters (16½ ft.) and then a yellow filter to about 13 meters (40 ft.) to improve contrast. Use no filtration at greater depths with natural light, but use the usual choice of filters for contrast control with electronic flash.

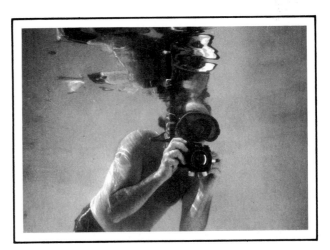

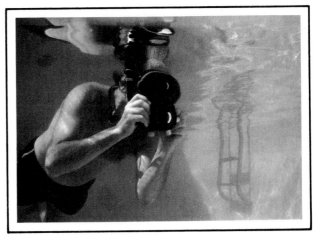

Even just below the surface in a pool, the light-filtering action of water reduces contrast. Proper filter choice can overcome the problem. (Above) A blue filter increases the problem because the water is bluish. (Below) A yellow filter blocks the excess blue and restores some contrast to the scene. Photos: H. Taylor.

8

Filters in the Darkroom

Filters have a variety of applications in the darkroom, including special effects in printing, control in black-and-white and color printing, and safelight illumination.

Selecting and using filters in the darkroom is relatively straightforward, and the quality with which filters are manufactured makes them long-lasting darkroom accessories. Their versatility in creating effects and providing printing control, and the waste of materials they avoid when used as safelights, also make darkroom filters an excellent investment.

Many camera-type special-effect filters have applications in the darkroom; for example, distortion, texture, and diffusion filters can be used to add expressive qualities to a print. Unusual combinations of color materials and filters also can create various effects.

Filters used for printing can alter image contrast in black-and-white printing, or color balance in color printing. Variable or selective contrast papers require filtered light to provide different degrees of black-and-white print contrast. These filters even can be used to print different local contrasts in the same image.

Many photographic materials have a limited sensitivity to various colors of light. Such papers and films can be handled under specific filtered light conditions for limited lengths of time without recording exposure or degrading an image to which they have already been exposed. This kind of lighting is called safelighting. The kind or color of filter required differs according to the material being used, and the location and strength of this kind of lighting must be carefully planned to insure that it is truly safe from a photographic standpoint.

These topics are discussed in this chapter. Although some special effects in color printing are explained, the ordinary use of filters for color printing control is not discussed. This is a topic you must become thoroughly familiar with when learning to make a color print. Its many details are outside the scope of this book.

The high-contrast lith films and papers which create prints like this are easy to use in the darkroom because they can be handled freely under red-filtered safelight illumination. Photo: E. Stecker.

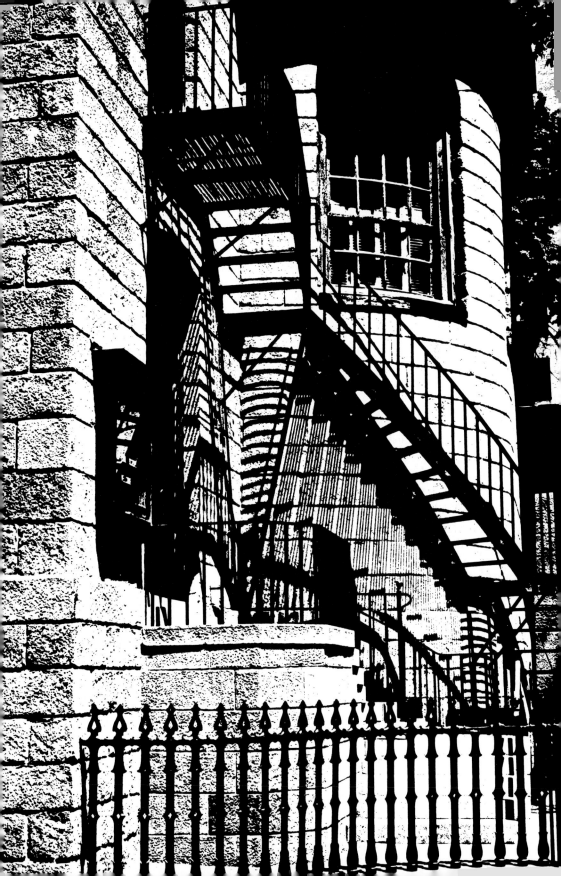

Special-Effect Filters in Printing

You can use special-effects filters in the darkroom for a wide range of creative control. Many filters that you use in front of the camera lens can also be used between the enlarger lens and the paper. There is also a special enlarging lens which accepts special effect elements inserted into an opening in the lens itself. Most special effects filters can be used in color as well as black-and-white printing.

Diffusion filters are useful for portraits as well as other types of pictures. They are available with different degrees of diffusion, so you can choose the amount of diffusion to be used with a specific picture. Using a diffusion filter during all or part of the exposure reduces image sharpness by slightly spreading the image-forming light. This gives a pleasing softness to the picture and spreads light in contrasting areas. You can also use this kind of filter to reduce distracting details such as scratches and grain. When enlarging negatives, a diffusion screen spreads the dark areas into the light areas of the image because a negative is most transparent in dark areas. This has an overall effect of reducing the brilliance of the print. In a reversal print from a slide or transparency the effect is the opposite: the highlights spread into the shadow areas. A diffusion screen with a clear hole in the center will produce an image with a sharp center and diffused edges. A circular diffusion disk lets you vary the amount of diffusion by changing the f-stop of the enlarger lens. The smaller the aperture you use with this type of filter, the less the diffusion.

Distortion and texture filters will add an overall pictorial effect to a print. Distortion printing filters come in a variety of types such as rippled-glass and cracked-plaster effects. Using a rippled-glass filter under the enlarger lens will give a print the appearance of having been taken underwater. The random cracks in a color picture printed with a "cracked plaster" filter add the effect of an old painting done on canvas.

Texture filters and screens work in a similar way to distortion filters. Some are designed to be sandwiched with the negative or slide above the lens, others should be placed between the lens and the printing paper to create their effects. Fabric mesh such as nylon or silk also can be used to create texture effects. The fabric should be stretched above the easel within 3mm (⅛ in.) of the paper to add its own texture without softening the focus of the picture. As a screen of this sort is moved closer to the enlarger lens its effect is less textured and becomes more diffused. Materials used for such screens should be black to reduce the risk of fogging the paper with scattered light.

Texture filters and screens, special-effect filters for the camera such as star filters, mirage filters, and a variety of other devices can be used to alter prints in many ways and to add a level of expressive control. Only experimentation can lead you to controlled, repeatable results.

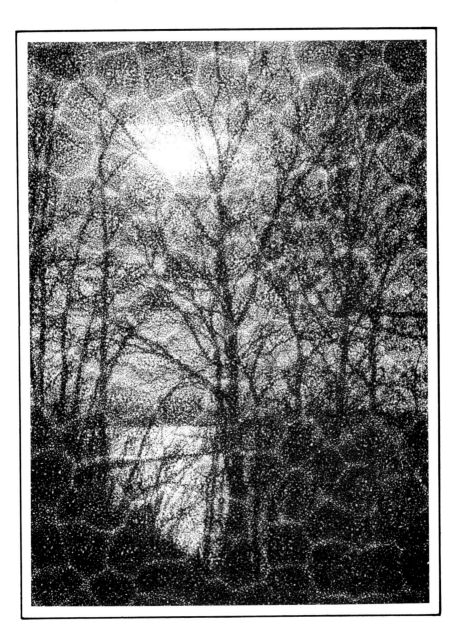

Texture screens used in printing are a kind of special-purpose filter. You can buy screens to be sandwiched with the negative in the enlarger, or make your own by photographing patterned materials on very high contrast film. You can also use large pieces of material on top of the printing paper as a kind of contact texture filter. That was the technique used here, with a sheet of textured glass. Photo: B. Bennett.

Color Effects in Prints

Using "wrong" color filters in printing a color negative or slide can create a picture with your own personal interpretation. Correction or contrast filters for black-and-white will add a strong overall color to a picture, because they are much stronger than color filters. These filters can create surreal landscapes and other strange special effects, adding an expressive dimension not found in straight printing. To obtain a particular color cast in negative color printing, you must use a strong filter of the complementary color. For example, to get a red picture, use strong cyan filtration. Use more than one color filter in combination to get colors other than primaries and secondaries. In reversal printing, use a filter of the *same* color to obtain a desired cast. (See the accompanying table.)

You can use a number of different approaches to achieve multiple-color and rainbow effects in color prints. Repeated exposures through different color filters, with the print masked in a different area each time can create a rainbow. Move the mask slightly and continuously during each exposure to blend the edges of the various color strips for a natural and realistic appearance.

Another method of achieving multiple color effects is to change filters and shift the printing paper slightly between successive exposures. Because of the great amount of overlapping, you must reduce each individual exposure to its fraction of the total exposure to avoid an overexposed, dense print with loss of detail. For example, if you are going to make eight exposures, give each one-eighth of the normal exposure.

The colors obtained with these special effects depend upon whether negative or reversal printing processes are being used. See the accompanying table for filter and color combinations.

A diffraction grating can also be used in color printing to form a spectrum of visible light from sources in the image, just as you would use it with a camera.

FILTER EFFECTS ON COLOR PRINT PAPERS

To Get This Color	Use This Color Filter With	
	Positive Print Paper	Reversal (Slide) Print Paper
Red	Cyan	Red
Blue	Yellow	Blue
Green	Magenta	Green
Cyan	Red	Cyan
Magenta	Green	Magenta
Yellow	Blue	Yellow

Note: You can get a primary color by combining two secondary color filters: C + M = B; Y + M = R; C + Y = G.

Photograms on color materials offer unlimited possibilities for experimenting with special effects. To make a photogram, lay opaque or translucent objects on print paper (or film) and expose them to white or filtered light. The image will consist of white silhouettes and colored semi-silhouettes in a strongly colored field. Making various exposures with different filters and objects can create a wide variety of effects. The first exposure on negative paper with one color filter will leave the object area unexposed and the paper exposed for the complementary color of the filter. A second exposure with different objects located partly over the previously unexposed area will create an image with a composite background color, contrasting color forms of the various objects, and some entirely unexposed areas.

For graphically unusual images try printing black-and-white negatives on color paper with filtered printing light. You can use multiple exposures through different filters to create a wide array of colors. This process will produce a negative image on reversal paper and a positive image on positive paper. The print will have overall colors determined by the filtration, and image details in white and various tints.

All these effects require experimentation on a trial and error basis until the results are predictable and repeatable. As with all printing techniques good notes, test strips, and standardized procedures help in the establishing of a workable process.

Variable Contrast in Black-and-White

Certain black-and-white printing papers offer you variable or selective contrast. These papers have two emulsion layers of different contrast, high and low; each layer is sensitive to a different color of light. Adjusting the color of the light striking the paper controls how much of the exposure affects each layer. In this way, one paper can provide different grades of contrast. This eliminates the need to stock several contrast grades of paper and the waste of a seldom-used grade going out of date before you can use it.

Variable-contrast filters have an overall range approximately equivalent to paper grades one through four. The filters at the low-contrast end of the range are yellow. They subtract blue from the printing light so that the exposure affects the green-sensitive low-contrast emulsion layer. The high-contrast filters are magenta; they subtract green light so the exposure affects the high-contrast blue-sensitive layer. Intermediate contrasts are achieved by filters which transmit various proportions of blue and green wavelengths to affect both emulsion layers in different degrees.

These filters are available as acetate squares which can be placed in the enlarger head to color the light transmitted through the negative, and as gelatin filters which can be mounted below the lens.

Subjects photographed in soft light (right) have less contrast in black-and-white than those in direct sunlight (opposite page). The resulting negatives need different contrast grades of printing paper. Variable contrast paper lets you stock just one box of paper to print negatives with greatly differing characteristics.
Photos: K. Tweedy-Holmes.

Split-Contrast Printing. Variable-contrast filters are most often used singly to balance negative contrast in order to get a correct print —one in which the diffuse highlights print just darker than pure paper white, and the shadow areas print just lighter than maximum paper black. This produces a print having detailed shadow areas with rich blacks, and detailed highlights with crisp whites.

However, some negatives require different grades of contrast to produce the richest results in various areas. This is impossible to achieve on ordinary graded papers, but can be achieved on variable-contrast papers by using more than one filter to make the print. This is called split-contrast printing.

Begin by exposing the print through a high-contrast filter to achieve maximum separation of details in the dark areas. The high-contrast filters are quite dense, so it is generally not necessary to dodge the highlight areas during this exposure. Next, change to a low-contrast filter to print in the highlights. It transmits more light than the high-contrast filter, so exposing these dense areas will be easier. However, during the highlight exposure you must dodge or mask-off the already-exposed shadow areas of the image to prevent excessive exposure. With careful blending of exposures between adjacent areas, the result can be an outstanding black-and-white image that could not be printed in any ordinary way.

Safelights

Safelights emit wavelengths that do not affect or fog photographic materials during normal working-time exposures. Safelight fixtures are available in a variety of types. The most common type has a standard low-wattage tungsten lamp and accepts interchangeable filters.

Safelights for Films. Like color films, panchromatic black-and-white films must be handled in complete darkness during processing. However, you can inspect black-and-white films under a safelight when at least half the normal developing time has passed. This procedure should be used only when absolutely necessary; it is not practical with color films.

Inspection development, as this procedure is called, is sometimes necessary in a case of significant over- or underexposure when you need to determine how much to shorten or extend the development time to get normal contrast in the image. You can inspect film under a dark green safelight filter used with a 15-watt bulb at a distance of no closer than 1.2 meters (4 feet) to the film. Do not expose the film to the safelight longer than 15 seconds. Make sure your eyes are completely adjusted to the dark before inspection; the process takes considerable experience to be effective.

Blue-sensitive films and orthochromatic (green- and blue-sensitive, or "red blind") films are not affected by red light, so they can be handled under red safelights. (See the accompanying table.)

SAFELIGHT FILTERS

Filter Designation and Color		Suitable for
OA	Greenish yellow	Black-and-white contact papers and films
OC	Light amber	Black-and-white contact and enlarging papers, including variable-contrast
No. 1	Red	Blue-sensitive films and papers
No. 1A	Light red	Slow orthochromatic films and papers
No. 2	Dark red	Faster orthochromatic materials
No. 3	Dark green	Panchromatic films and papers
No. 7	Green	Black-and-white infrared materials (except Kodak Highspeed Infrared Film)
No. 8	Dark yellow	Color print and color intermediate negative films
No. 10	Dark amber	Color negative papers, color slide and print materials, panchromatic papers
No. 13		Color negative and panchromatic papers

Safelights for Printing. Safelights are most widely used to provide working illumination for black-and-white printing. Safelight illumination is generally brighter at the developer tray position than in other areas of the darkroom. However, the level of illumination must be low enough to be safe for the maximum working time. If the illumination is too bright, it can cause lower print contrast and degraded highlights. The major causes of safelight fogging of papers are incorrect safelight filters, faded filters, safelight too close, bulb of too high a wattage, and too many safelights in the darkroom.

Color films and papers are sensitive to all colors of light. However, because color papers are less light sensitive than films, in certain cases they can be handled under safelights. Check the manufacturer's instruction sheets to determine correct safelight filtration. You can determine whether your safelights are suitable by making the test described in the Technique Tip. The accompanying table makes filter recommendations for a variety of photographic materials.

Index